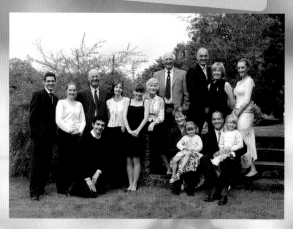

START TAKING GREAT
FAMILY
Photographs

Mark Cleghorn

photographers'
pip
institute press

First published 2007 by

**Photographers'
Institute Press / PIP**

an imprint of
The Guild of Master
Craftsman Publications Ltd,
166 High Street, Lewes,
East Sussex BN7 1XU

All text and photography © Mark Cleghorn 2007
© in the Work Photographers' Institute Press / PIP 2007

ISBN-10 1-86108-488-9
ISBN-13 978-1-86108-488-0

British Cataloguing in Publication Data.

A catalogue record of this book is available from the British Library.

Production Manager: Jim Bulley
Managing Editor: Gerrie Purcell
Photography Books Project Editor: James Beattie
Managing Art Editor: Gilda Pacitti
Designer: James Hollywell

2

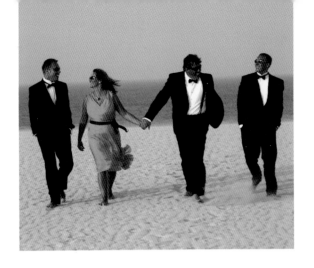

START TAKING GREAT
FAMILY
Photographs

Mark Cleghorn

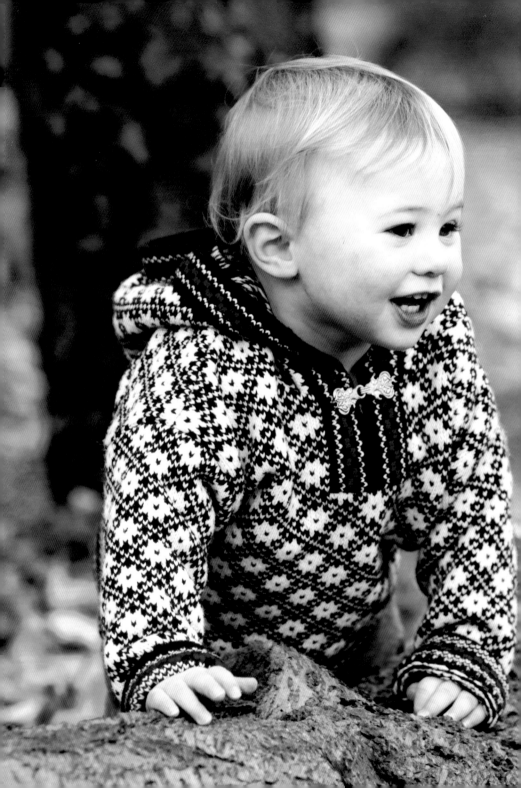

Contents

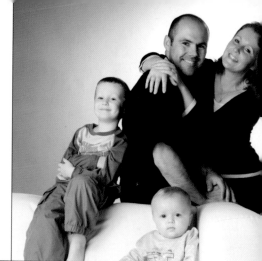

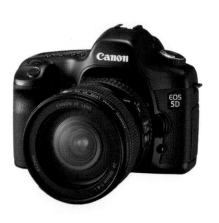

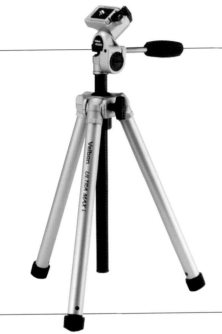

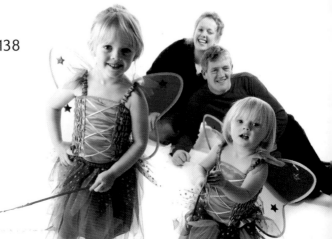

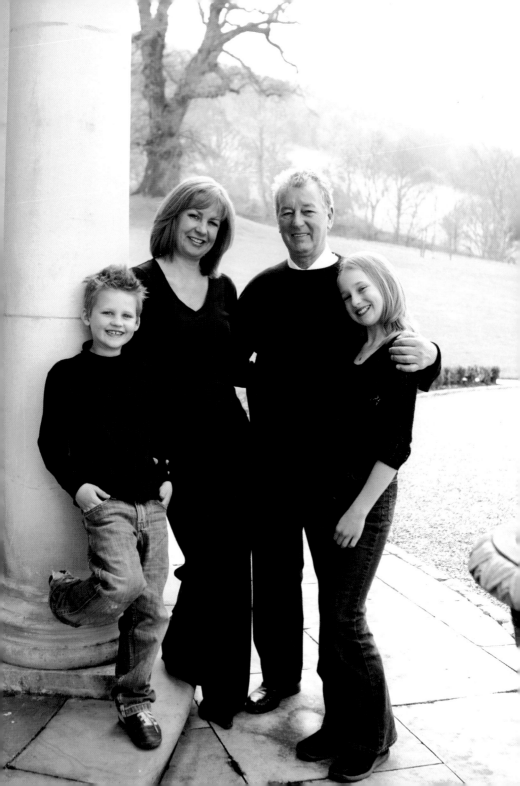

Introduction

◄ Great family portraits can be achieved every time if you understand your camera equipment and how to light and pose the subjects, but remember the main thing is not missing the picture.

There is nothing more disappointing than thinking that you have taken a great family portrait, only to be let down when you actually see it in print. Well don't worry too much because it happens to most photographers at some stage. Photography is a learning process and as you gain skills and experience so your results will improve, allowing you to capture not just a technically sound shot of the occasion, but an image full of emotion.

There are some simple rules to follow to get great family photographs and not all of them are to do with a camera. This book will help you understand some fundamental photographic techniques that will not only allow you to choose and use your equipment more effectively, but also to explore and develop your lighting and posing techniques as well as your people skills, helping you achieve far superior results.

Each chapter of this book is designed to push you one step further to allow you to think and shoot like a professional when capturing those special memories, which are often unrepeatable. There are some simple solutions to most photographic challenges and knowing about the problems and how to avoid the pitfalls before they occur is the secret to success; so I have included some simple tricks to get you out of trouble no matter what the occasion.

To help you continue to improve your key skills I have included some simple exercises to make sure you are pushing and understanding your camera technique as well as to assess your images, so as to know when to apply the tips and tricks effectively. It takes some effort and a little experience, but if you apply the techniques in this book you will take great family portraits.

WHAT MAKES A BAD FAMILY PHOTOGRAPH?

- Common Mistakes

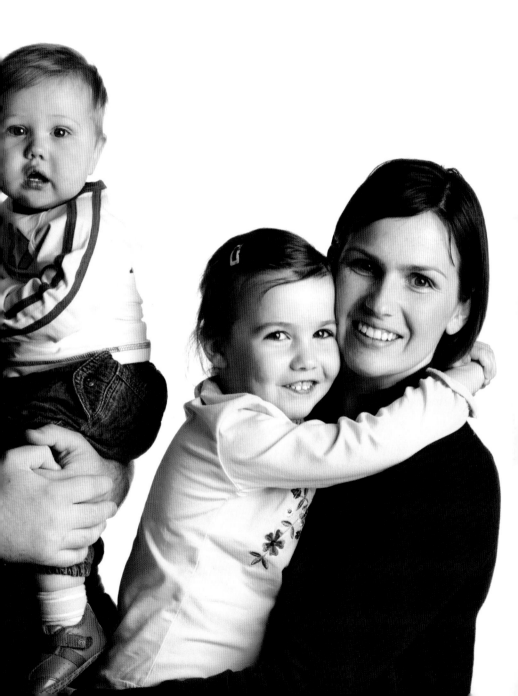

ONE **COMMON MISTAKES**

To take good family pictures is not too difficult, but it is so easy to get it wrong from the start by ignoring some simple rules of thumb. This section will cover the most common errors; things that are easily avoided, but often spoil a photograph.

A great family photograph is hard to define as you will obviously be biased when it is of someone dear to you, but the key to any good image is sound technique. On top of this, emotional contact with the subject is what makes the difference between a good and a great photograph and it can be seen in photographs that are full of life. With a little attention to detail and some basic rules applied to each photograph you will start taking better images straight away. So let's iron out some common mistakes to start with.

POOR COMPOSITION

Many people believe that composition is an intuitive skill, something that cannot be taught. However, this isn't true: the more you practise the better you get, and there are plenty of hints and tips that will help you to hone your compositions and create slick-looking shots with plenty of impact. There are also a few pitfalls to watch out for, so check the following pages for what to avoid.

>> **SEE** pages 13–17 for some examples of how poor composition can let you down.

POOR CAMERA TECHNIQUE

Digital cameras now allow you to see errors before it's too late, which is great for family photographs taken at events such as weddings that will never happen again; however, the LCD screen won't show you everything and you should still understand how your camera works to give you the basis to think creatively.

>> **SEE** pages 18–26 for some examples of how poor camera technique can let you down.

✖ Bad Cropping

Poor cropping of people's hands, feet and heads is the biggest error that most photographers make in framing the image. This often occurs when a photographer is rushing and not paying attention to detail in the viewfinder. Cropping off the tops of people's heads can also be the result of pressing the shutter-release button too hard, causing the lens to drop slightly; breathing heavily can also cause mistakes as the camera rises and falls slightly as you breathe; while holding a digital camera at arm's length can also make accurate cropping tricky. Of course choosing the wrong lens or even the wrong focal length on a zoom lens can also be a source of problems.

>> **GETTING IT RIGHT** pages 110–111

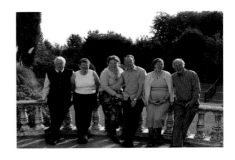

▼ ▲ *Portraits can be spoilt by simple cropping mistakes. In the shot above the feet are cropped off by mistake – a common problem with digital compacts. Good cropping is all about capturing the important part of the image. Below, the tops of the heads are cropped off intentionally to get closer to the eyes, smiles and baby.*

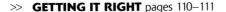

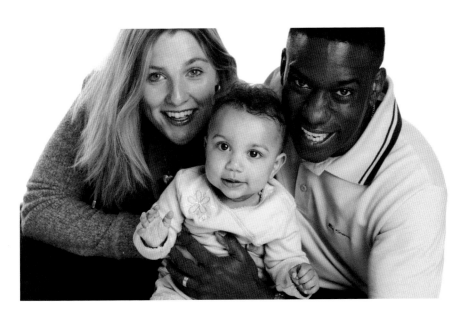

❌ Bad Grouping

A key reason why some family shots don't look right is the arrangement and posing of the subjects, especially when a portrait is of a group. People, of course, come in different shapes and sizes and should be positioned accordingly. Putting children at the front of a group is a good idea, but as they grow up they may become too large to be at the front as they will often cause obstruction to other family members. Crowded groups will often adopt forced poses, so try to make sure that there is space for people to be easily seen by the camera without the need for them to adopt artificial poses.

>> **GETTING IT RIGHT** pages 98–9

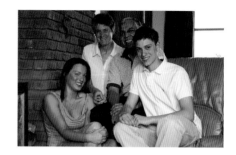

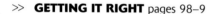

▼▲ *If a subject is placed too far in front of another, above, this will often spoil the shot as the subject behind will try and peer around them. The group below has been given more space by asking the boy on the right to sit further back on the sofa.*

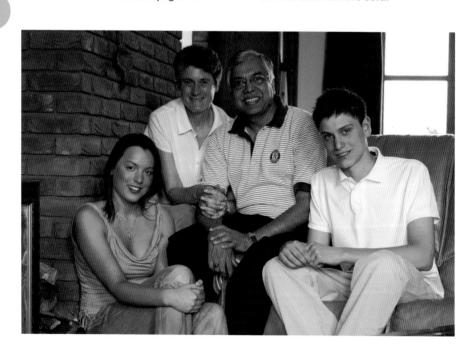

⊗ Poor Expression

▲ *Children easily lose interest so make a photo shoot quick with little equipment and fuss.*

Getting people together and organizing them is a key skill, but arranging them and knowing when to take the picture is a knack that comes with practice. Sometimes the picture is taken too late and the subjects, especially young children, will have lost interest. When this happens the children will start to look away, misbehave or even cry. The direct result of this is that your attention will have to be focused on the children and some of the other subjects will also lose interest and start to look away from the camera.

▼ *Communication and distraction is the key to keeping kids interested and getting a good expression.*

>> **GETTING IT RIGHT** pages 100–109

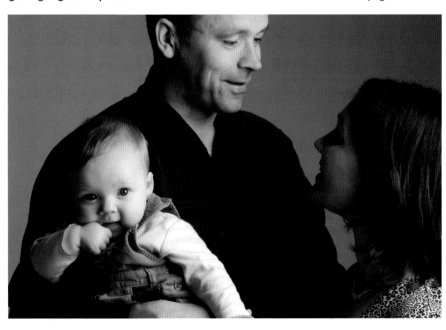

✖ Bad Composition

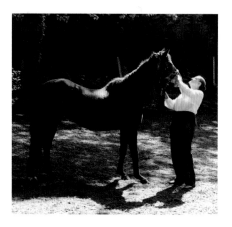 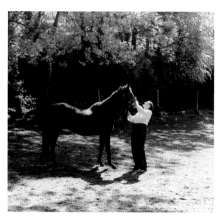

Composition is often about balance and creating images that 'feel' right. Shots that are badly constructed and posed will often feel imbalanced and the image can appear as if it leans to one side.

When shooting groups you should consider who is the main subject and then position everyone around them, if not the group may be imbalanced and probably will not look quite right even though you can't put your finger on the problem.

The same sense of imbalance can occur if there are more people on one side of a group than the other. If a lot of space has been left around the subjects to include a view or a building, simple composition rules, such as the rule of thirds (see page 110), are often broken which again can throw off the balance of the picture.

Another problem is allowing too much space around the subject, particularly when they are centred, leaving the subject looking detached from the portrait especially if they are looking directly into the camera lens.

▲ *The wrong lens choice can lead to excessive space around the subject, as is the case in the photograph immediately above where there is too much space given to the grass in the foreground and the trees in the background. Even though bad composition can be improved with slight cropping on computer or in a frame it is always better to get it right first time, as in the shot above left.*

>> **GETTING IT RIGHT** pages 110–111

⊗ Background Clutter

◀ *A simple background should add to the overall impact of the image. This subject was only moved a short distance away from the cluttered background in the image below and placed in front of a contemporary water feature which reflects some of the colours and shape from the surrounding area.*

▼ *A cluttered background will always distract the eye in the final print. If you are unable to move location try using a wide aperture (see pages 68–9) to throw the background out of focus.*

The background plays an important role in any image, but is often ignored by inexperienced photographers; often simple things such as guttering running down a building and behind someone's head are enough to spoil an image. Similarly, gravestones in churchyards are a common flaw in what should be happy family portraits at weddings. When indoors look out for clutter such as plants and furniture – a wall light growing out of someone's head is a classic mistake. The solution to all these problems is avoiding these distractions or hiding them, so always scan the location, indoors or out, carefully.

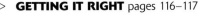

>> **GETTING IT RIGHT** pages 116–117

✖ Too Much Flash

Overuse of flash is a basic error which can be caused by several things, the most common of which is the aperture being set too wide and hence the image being overexposed. Even when shooting digitally anything badly overexposed is basically unprintable, even when shot as a raw file and corrected on computer (see page 82).

The portrait can also be overexposed by the flash itself, if the subject is too close to the camera and flash. This overexposure is more common with basic compact cameras as SLRs have much more sophisticated metering systems.

Small off-camera flash units (also known as speedlights), which attach to the camera via a hotshoe mount on top of the viewfinder, are so sophisticated today that problems are usually the result of human error in setting up the flash, rather than the fault of the flash unit itself.

Even a professional studio flash unit with its power output set too high will give overexposed results, just like setting the aperture on the camera too wide for a given power setting will.

>> **GETTING IT RIGHT** pages 46–57

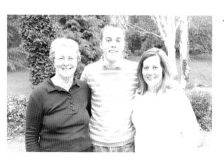

◀ *Too much flash is quite common with small compacts as is the case with this image. The on-camera flash has severely over-lit the subjects making the shot unprintable even after adjustments in Photoshop.*

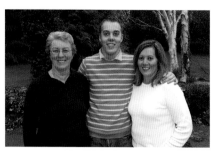

◀ *The corrected image was simply achieved by changing the compact camera metering mode (see page 71). The correct exposure now gives a full tonal range and is easily printable.*

❌ Not Enough Flash

If the subject is in a low-lit room or outside at night the flash may not be powerful enough or the subjects may be too far away to give a correct exposure.

Using a professional studio flash and setting the power too low will also give underexposure, the same as using an aperture too small for the flash setting.

A flash not firing is also a common problem. It may not have had enough time to recycle its charge or with an off-camera flash the connection cord may either not be attached correctly or is broken, or with an infrared connection a unit might not pick up enough of the infrared beam to fire.

▲▲ *When the camera thinks there is enough light or the flash fails to fire the image can be dark with little or no detail in the shadows. A subject looking to camera often has very dark-socketed eyes as seen above. Fill-in flash was used to lift the overall detail and illuminate the face in the shot at the top.*

>> **GETTING IT RIGHT** pages 46–57

⊗ Camera Shake

Even hardened pros can only hold a camera for so long without the effects of camera shake becoming visible and it seems the older you get the faster the shutter speed needs to be keep things pin sharp. One of the biggest problems I see when judging print competitions is images that have slight camera shake giving a faint double image; especially when flash is combined with slow shutter speeds which can produce a ghost effect.

Camera shake usually occurs when using slow shutter speeds. Don't risk slow shutter speeds without a good tripod as the bigger the photograph is enlarged the more apparent the shake will be. The longer the lens you are using the harder it is to avoid camera shake when you are holding the camera. This is because a heavier lens is harder to hold still and the effects of camera shake will be magnified by the longer focal length.

>> **GETTING IT RIGHT** pages 78–9

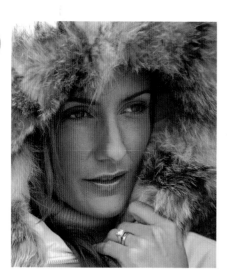

◄ *To avoid the image suffering from camera shake a tripod can be used to steady the camera. This will allow a slow shutter speed to be used as in this shot to the left, to add movement to the fur but still keep the subject sharp.*

▼ *Camera shake, as seen below, is common when the shutter speed is slow because the light is too low or the wrong ISO is set and the camera is handheld.*

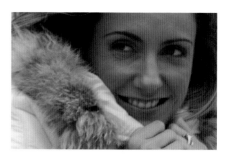

ⓧ Shutter Lag

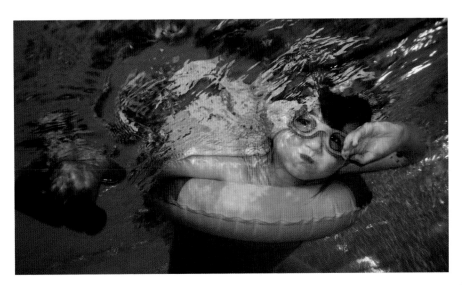

The delay between pressing the shutter-release button and the camera actually taking the photograph is referred to as shutter lag. This is negligible with film cameras and modern digital cameras, but older digital compacts suffer a lot with this problem, they exaggerate the delay between the pressing of the button and the taking of the picture, hence missing out on fleeting moments.

The shutter lag alone is frustrating but when combined with moving subjects such as children, who are never still for long, the delay in taking the picture seems a lifetime, as the child is usually halfway out of frame before the picture is taken. There's not much that you can do apart from invest in a more up-to-date model.

▼▲ One of the most frustrating aspects of older digital compacts is the shutter lag causing you to miss the action. In the photo below the little girl has had to resurface for breath and the shot is ruined. However, the great thing about digital cameras is you can shoot as many images as you wish to get 'the one', above, without the cost of having to buy, develop and print lots of film.

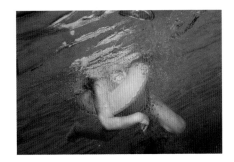

>> **GETTING IT RIGHT** pages 32–7

✖ Vignetting

▲ *If the wrong lens hood is used or a 'pro hood' is extended too far it will result in a vignetting of the corners of the image or as seen here on the top and bottom. However, this should be visible through the viewfinder.*

The vignetting I refer to here is that caused by obstruction rather than that used for aesthetic purposes. Typically a camera strap or a finger on the lens is the source of the problem, and while it is still a problem with digital compacts it is a lesser one now due to the digital screens on the backs of the cameras, where the dark patches caused are far easier to see and rectify.

If you have a lens hood attached to the front of your lens be aware of how far it extends, as it can creep in on the edges of the frame. Even a pro vignette filter used incorrectly will not add drama and impact to a portrait as it is designed to do but can result in a defining edge and the shape of the vignette filter, instead of a subtle effect to bring the eye of the viewer straight to the subject.

>> **GETTING IT RIGHT** pages 32–7

▶ *A dark out-of-focus patch on the image is usually the result of a camera strap, a finger or any other obstruction dangling in front of the lens.*

❌ Selecting the Wrong Lens

Using a wideangle lens, or for that matter a zoom at its widest setting, too close to any subject will distort the features, the shorter the focal length the bigger the problem. The lens will give a slight bulge to the subject increasing the perceived size of a person, making them appear fatter than in real life or even giving them out-of-proportion features.

A long lens, however, will not allow you to be intimate with the subject because you will have to photograph them from further away, especially if you are photographing a group that you need to fit into the frame.

Moderate telephotos are the standard lenses for portraiture, but the right lens is the one that captures the effect you want.

>> **GETTING IT RIGHT** pages 38–43

▲ *Sometimes there isn't really a wrong lens but perhaps a different lens would give a better result. I like using a mid-range wideangle at times to give a quirky look to the portrait.*

▼ *These three images below show how a longer lens gives a more realistic-looking portrait.*

ONE

23

COMMON MISTAKES

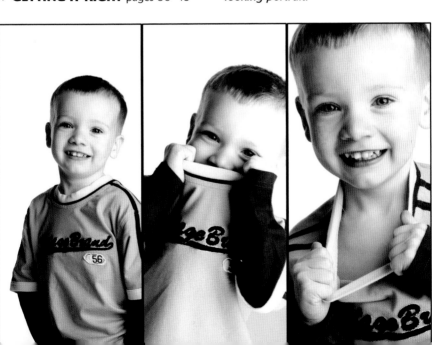

⊗ Bad Lighting

While good lighting can make a photo, bad lighting will break it. Bad lighting takes many different forms, sometimes the light won't be suitable for good photography while sometimes it will create challenges beyond the photographer's or the camera's capabilities. For example, when the subject is backlit a simple compact or even a more sophisticated camera set to auto, may struggle, giving an underexposed subject. Lens flare may also be a problem as sunlight coming straight at the lens can cause coloured polygons to fill the frame and also result in a general loss of contrast and sharpness.

Harsh lighting on faces is a common problem on sunny days; it can cause high-contrast that looks unpleasant and forces the subjects to squint. However, while gentle shade, such as that of a tree, can give softer lighting, positioning a subject too far into a wood will result in low-contrast light that doesn't define shapes well.

You should also assess the colour of light; at either end of the day it has a nice warm cast, while during the middle of the day it has cool tones. Light's colour is also affected by reflection or diffusion; for example, light diffused by the foliage of a tree may have a green tinge.

>> **GETTING IT RIGHT** pages 84–93

◄▼ *If the subject is too far under the canopy of the trees, they may have a green cast, left. Moving the subject out from under the trees, below, will give crisp white light giving more form to the features, hence a better portrait.*

◀ *Here the subject took one step back to use the shade of the window surround in order to give a softer overall lighting which the camera's metering coped with far better than the harsh lighting in the shot below.*

▼ *When strong sunlight hits the subject it often gives automatic metering systems a problem, sometimes resulting in a very overexposed image.*

Getting the exposure wrong is still a problem even in today's automated world. It is not always the camera's fault, but setting a camera to automatic does not give you much control, and when faced with difficult lighting conditions will often lead to unsatisfactory exposures.

When a subject is struck by strong, direct light the shadow areas become darker and the highlight areas lighter. Faced with this a metering system will often struggle and this may result in over- or underexposure leaving the image with burnt-out highlights and increased contrast when overexposed or muddy shadows with little detail in underexposed images.

>> **GETTING IT RIGHT** pages 70–5

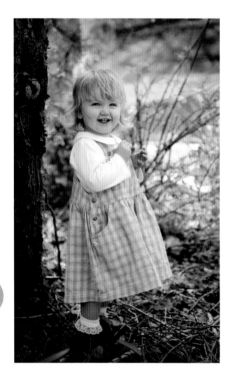

▲ *When good focus is achieved the camera usually responds with a slight beep noise and a visual indicator, but make sure its focus is on the subject.*

We are becoming more and more reliant on autofocus cameras and lenses, mainly because it is easier as well as quicker than focusing manually, most of the time it is also more accurate than our own eyesight. However, it is essential to understand your camera's ability to focus, and to develop some techniques for focusing creatively; fundamentally you have to be able to get the main subject sharp.

Autofocus often struggles in poor light and when the subject is offset to one side, which can lead the autofocus to lock onto the background or foreground instead of the subject. Understanding your autofocus system is vital, but focusing manually can be the answer; while controlling the depth of field is also important as it allows a certain envelope, from foreground to background, to appear sharp.

>> **GETTING IT RIGHT** pages 64–9

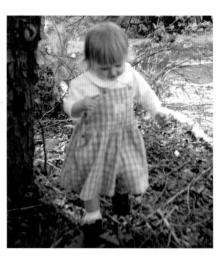

▶ *The subject being out of focus is often caused by the camera's autofocus facility selecting something in the front of or behind the main subject.*

To try and improve your skills more quickly, use these exercises to highlight the areas of your technique that need to be improved the most.

1 Select 10 or 12 of your photographs and then ask the questions below of each image and group of images.

2 Now read the techniques explained in Part II and consider what you would do differently to improve your shots.

3 Next time you find yourself in a family situation with your camera think back to the methods that you have learnt about and try to apply them while you are taking pictures to get better results.

Y	N	
☐	☐	Have you cropped out any hands, heads or feet or can you crop the portrait tighter to enhance it? If yes, see pages 110–111.
☐	☐	Does the subject look natural? If no, see pages 94–109.
☐	☐	Is there anything that distracts the eye or could the picture been improved with a simpler background? If yes, see pages 116–117.
☐	☐	If you have used flash does it look unnatural or has it been insufficient to light the subject? If yes, see pages 46–57.
☐	☐	Have you chosen the lens that gives the effect that you were looking for rather than simply choosing one for convenience? If no, see pages 38–43.
☐	☐	If the light doesn't flatter the subject could you have shot at a different time of day? If yes, see pages 84–93.
☐	☐	Is there a good range of shadow and highlight detail in your image? If no, see pages 70–75.
☐	☐	Is the main point of the image in sharp focus? If no, see pages 64–7.
☐	☐	Have you captured the best expression? If no, see pages 94–109.

HOW TO TAKE GREAT FAMILY PHOTOGRAPHS

•

Equipment

•

Technique

•

Lighting

•

Practical Posing

•

Composition

•

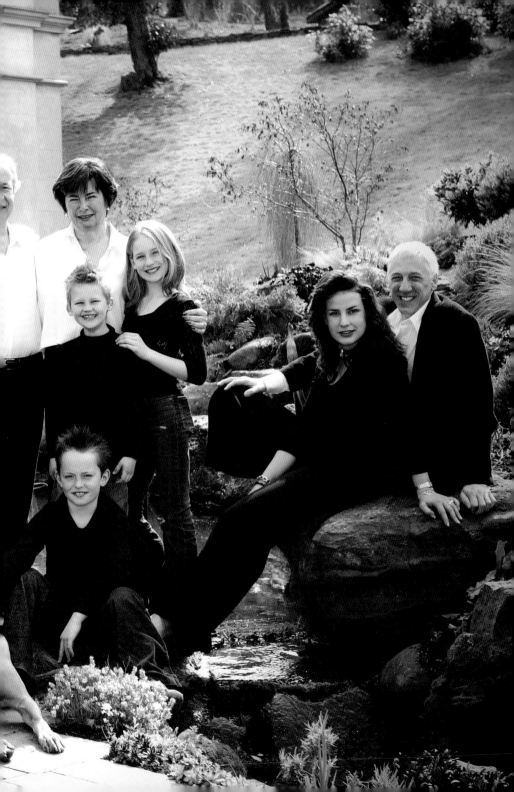

TWO **EQUIPMENT**

It is essential to buy the best equipment you can, but it also has to be the right kit for you and for what you are planning to shoot. The right equipment should allow you to shoot quickly and with little fuss, so you can spend more time on capturing expressions and the correct pose as well thinking creatively.

Cameras and Formats

Buying a Camera

Check out the Internet for the latest reviews and comparisons of cameras. This will take a lot of the headache out of selecting a specific camera as well as telling you of any potential problems or quality issues.

It's obvious that different cameras will do different things and there is no perfect camera to take family shots, but without doubt some cameras will do a better job than others – especially as far as speed and quality are concerned. There are several key things to consider before buying equipment and probably the biggest one at present is film or digital.

For myself and most professionals the obvious choice is to shoot digital due to its lower running cost and the quality of the image; however, film cameras are still available and do have their own plus points. So, over the following pages we'll look at the advantages and disadvantages of each type of camera.

✔ Your camera should be comfortable to hold so go into a store to hold and feel the camera.

✔ You will often need to hold your camera for long periods at family occasions so check that it is not too heavy before you buy it.

✔ The better the autofocus system the greater benefit it will provide, especially for fast-moving subjects such as children playing.

✔ An optical viewfinder is often easier to use than an LCD screen, allowing you to concentrate on the subject and react more quickly to movement and expressions.

✔ When choosing a digital camera get one with at least eight megapixels. This will allow you to print large portraits for your walls.

✔ On-camera pop-up flash is useful at times for lighting the subject in dark locations and for filling in shadows.

✔ If you plan to use off-camera flash, or studio lighting for your portraits, you will need a flash-synch connection or hotshoe on the camera.

✔ A standard tripod socket is useful for low-light situations.

✔ A variety of exposure options will allow you to control the aperture and the shutter speed.

✔ A wide range of ISO ratings (a minimum of ISO 100 to ISO 800) with low noise at the higher ratings will make shooting in low-light conditions a lot easier.

TWO

31

EQUIPMENT

POCKET-SIZED COMPACT CAMERAS

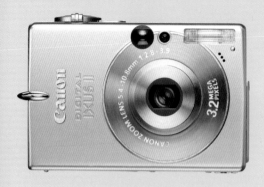

There is nothing basic about any film or digital compact camera today, but the more compact models often have limited functionality especially if you are trying to get a more professional-looking image and have some creative control. However, you can slip them into your pocket so they are more convenient.

 ## ADVANTAGES

Usually relatively cheap.

Very small, compact and light.

Easy to get to grips with and no need to spend a lot of time learning how to use.

Point-and-shoot functions mean that all you have to think about is composition.

Most have a built-in flash that is useful as a fall-back option.

Most models feature basic autofocus as well as a limited zoom lens.

You cannot change lenses so dust cannot enter the camera and adhere to the sensor.

 ## DISADVANTAGES

Normally mediocre image quality compared to larger cameras because of restrictions on the size of the sensor in digital compacts and the optics in both film and digital compacts.

It can be impossible to override some functions to exert creative control.

Sometimes they offer a digital zoom which degrades the image quality unlike an optical zoom. Any optical zoom is not likely to have a very large range, however.

There is often no optical viewfinder.

There can be a lag between pressing the shutter-release button and the shot being taken.

The built-in flash is not very powerful, sometimes inadequate for night shots.

HIGH-SPEC COMPACT CAMERAS

Only really available as a digital option these are perfect for the photographer who wants more creative control, but still wants ease of use in a package that is smaller than an SLR. The quality of the image is usually higher than with pocket-sized compact cameras, but lower than that offered by an SLR.

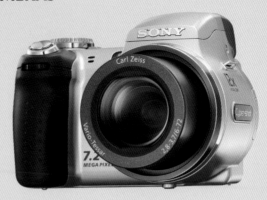

 ADVANTAGES

Cheaper than a digital SLR and relatively compact, although not pocket sized.

Easy to use with little set-up and advanced point-and-shoot settings allow for simplicity of use in a variety of situations.

The built-in flash is more powerful than those of pocket-sized compacts. They also include an off-camera connection and a hotshoe.

Normally a wider zoom range and a wider ISO range as well as a more accurate and flexible autofocus system than pocket compacts.

Some models have an optical viewfinder and a rear LCD.

You cannot change lenses so dust cannot adhere to the sensor.

 DISADVANTAGES

Lower image quality than provided by a digital SLR.

While you can normally override some functions they can be difficult to access.

Not all models have an optical viewfinder as well as a rear LCD.

Some have a slight shutter lag compared to SLRs.

Most use more basic exposure and autofocus systems than are available on SLRs.

Few have a built-in flash that is as powerful as SLRs'.

35mm FILM SLRs (SINGLE-LENS REFLEX)

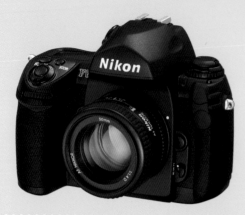

Days are limited for this once must-have camera due to the falling cost of digital SLRs. However, the quality of film which is available makes the 35mm film SLR an easy entry into more professional-looking portraits without having to learn digital skills as well.

 ADVANTAGES

Lower initial cost, smaller and lighter than the majority of digital SLRs.

Simpler to use than digital cameras, but more flexible and with faster autofocus than compact cameras. Lower battery usage than digital cameras.

Transparency film offers higher quality than most compact digital cameras.

Compatible with a variety of lenses, flash units and accessories.

Many advanced point-and-shoot settings.

The built-in flash is more powerful than those of pocket-sized compacts. They also include an off-camera connection and a hotshoe.

Through-the-lens viewfinder.

 DISADVANTAGES

The small film format limits the extent to which images can be enlarged.

The range of the ISO is limited to that of the selected film.

Auto functions and technology can make you lazy.

The running costs of processing and buying film are higher than the running costs of digital cameras.

AMATEUR DIGITAL SLRs

Falling prices and advances in technology have made this once expensive camera very affordable to the majority of photographers. Entry-level DSLRs now rival the quality of transparency film, and they are now the most popular camera for serious amateurs.

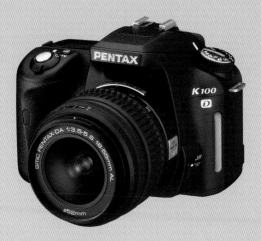

 ADVANTAGES

Cheaper, lighter, easier to use and more compact than pro DSLRs.

Lower running costs than film cameras.

Instant image review. Advanced point-and-shoot settings that remove most of the technical worries, but still allow some control.

Wide variety of interchangeable lenses.

The built-in flash is more powerful than on compacts; include an off-camera connection and a hotshoe.

Shoot in raw format to allow more accurate post-production.

Quick autofocus as well as a wider range of focus points.

Through-the-lens viewfinder.

 DISADVANTAGES

Smaller sensors generally mean lower-quality and lower-resolution images than pro DSLRs.

Fewer frames per second and smaller bursts than pro DSLRs.

It can be a slow process to override automatic functions.

Lower build quality than pro DSLRs and some film SLRs.

Fewer functions than on pro DSLRs.

Sensor will need cleaning occasionally due to dust adhering to it, although some models minimize this.

PRO DIGITAL SLRs

Pro DSLRs with 12 megapixels and above will give you the quality that a professional expects. Combine this with a solidly built camera that can withstand heavy usage, more advanced autofocus and exposure systems coupled with a realistic price and there is no excuse not to shoot like a pro.

 ADVANTAGES

High image quality and resolution.

Fast drive rates and instant image review as well as large buffers.

Wide variety of interchangeable lenses.

Hotshoe for external flash as well as an off-camera synch connector for studio flash cord.

Quick autofocus as well as a wide range of focus points.

Through-the-lens viewfinder.

No cost of film or processing.

Wide range of models and prices.

Shoot in raw format to allow more accurate post-production.

 DISADVANTAGES

High initial cost.

More complicated and less user friendly than amateur models.

File sizes can be very large so good file management is essential.

Heavy compared to entry-level DSLRs.

Require cleaning because dust can adhere to the sensor.

MEDIUM-FORMAT CAMERAS

A different league of camera for both film and digital. The medium-format camera was the professional portrait and wedding photographer's choice of camera for film and now is the commercial photographer's choice for digital. The larger image area gives a very high quality image, superb for any application.

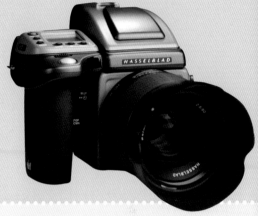

 ADVANTAGES

Image quality is fantastic.

There are a variety of lenses and accessories available.

Both manual and autoexposure settings.

Off-camera synch and hotshoe for advanced flash.

The larger sensor or film makes for higher-quality final prints.

There is a good range of models and prices particularly second-hand film models.

Interchangeable backs for different film types or digital sensors.

Older second-hand film models are relatively cheap.

 DISADVANTAGES

Digital models are extremely expensive.

Little automation compared to SLRs and compact cameras.

File sizes are large and require good management.

High degree of digital skill needed to use correctly.

Heavier than SLRs.

Require cleaning from time to time due to dust on sensor.

Some film models lack autofocus.

Lenses

L ens choice will either make you a lazy photographer or a creative photographer and it all depends on what lenses you decide to buy and use. A lazy photographer will select a longer lens or a zoom to fill the frame instead of changing the camera-to-subject distance. A creative photographer will choose the correct lens for the style of shot that they want to take; whether it be a funky wideangle close-up or just a tight section of the subject.

>> **SEE ALSO**
Depth of field, page 68

ZOOM OR PRIME LENSES

A zoom lens has a variable focal length while a prime lens has a fixed focal length. These days there is little difference as far as sharpness and contrast of the image are concerned when comparing a good-quality zoom lens and a good-quality prime lens. This is due to the vast improvements over the years by manufacturers.

A zoom lens makes sense for most shots as it allows quick alterations to the cropping of the frame especially with groups when time is of the essence.

A fixed focal length lens, known as a prime lens, will usually be lighter due to there being fewer elements in its design and often feature a wider maximum aperture that makes it more useful in low-light conditions.

Lens Quality

The lens is key when it comes to quality; a cheap lens may lead to a loss in contrast and sharpness, so choose your lens carefully.

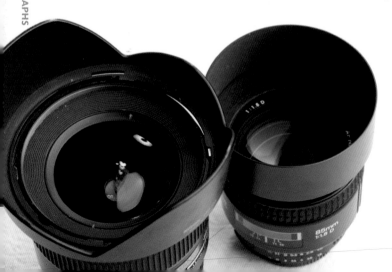

FOCAL LENGTHS AND ANGLE OF VIEW

As I have said there are two basic types of lens, zoom and prime, but there are also three basic groups of lens as far as focal length is concerned: wideangle, standard and telephoto.

In basic terms the shorter the focal length, the wider the angle of view; the larger the focal length, the narrower the angle of view. A wideangle lens will create a wider angle of view than the human eye, a standard lens sees more or less what we see with the naked eye and a telephoto lens has a narrower field of view. From a fixed viewpoint a wideangle lens will show a low subject magnification, while standard and telephoto lenses will offer progressively higher magnifications.

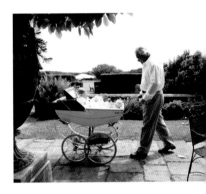

▲ *A zoom lens is great for fine-tuning your cropping.*

The right lens for the job

You should try to obtain a good range of lenses from wideangle to telephoto that will allow you to choose the right lens for the job rather than having the style of photo dictated by the lens that you have available.

39

Wideangle lenses

A wideangle lens can be used for dramatic portraits as well as for fitting in large groups in tight situations. It's an exciting lens to use in contemporary portraiture by exaggerating the field of view and including objects, architecture and even people that ordinarily would have been cropped out. Try to avoid using it as your basic lens for groups as the angle of view may appear to make subjects bulge or appear distorted when used close-up.

▶ *A wideangle lens is useful for shots that include large numbers of people or when you want to place the subject in the context of their background.*

Standard lenses

A digital SLR with a small sensor has a standard lens of approximately 35mm. Full-frame DSLRs and 35mm film SLRs both have a standard lens of 50mm. A medium-format 6x6 camera has a standard lens of around 80mm.

▶ *A standard focal length lens is good for providing images with a more natural perspective.*

▼ *A short telephoto is ideal for more closely cropped portraits with a more flattering perspective.*

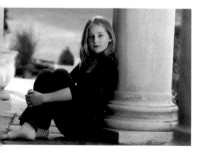

Standard lenses

The standard lens is an excellent all-round lens; mainly used for three-quarter and full-length portraits it gives a natural perspective and does not distort the subject. It also allows you to stay close to the subjects, so you can instruct them easily.

The only real downside with a standard lens is they offer greater depth of field than telephotos so subjects often do not separate as easily from the background.

Short telephoto lenses

A short telephoto lens is excellent for tightly cropped portraits, such as a basic head-and-shoulders shot, when used to fill the frame. A short telephoto lens gives a more natural perspective than a standard lens as it can be used from a slightly greater distance and gives no exaggeration to the features, hence it gives a more appealing portrait.

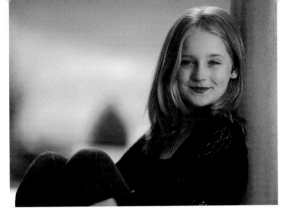

◀ *A long telephoto lens helps separate the subject from the background.*

Long telephoto lenses

If you are trying to make the background go out of focus on full-length portraits then this is the lens to use. Again, it gives a natural-looking subject but with the perspective of the background being foreshortened by the distance from which you need to use it. It is also great for cropping in further on the subject to create a more intimate feeling than shorter lenses allow.

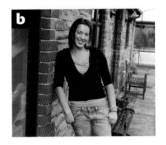

MAGNIFICATION

Magnification of an image is simple to see, but more difficult to explain; so, in simple terms, when increasing the focal length of the lens and maintaining camera-to-subject distance a greater magnification of the image is achieved. This is a linear relationship so doubling the focal length will double the subject's magnification and vice versa, provided the camera-to-subject distance remains the same.

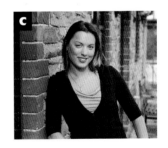

▶ *Increasing the focal length without moving the camera position increases the magnification of the subject within the frame.* **a)** *24mm,* **b)** *50mm,* **c)** *100mm,* **d)** *200mm.*

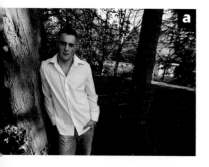

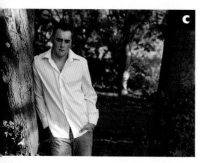

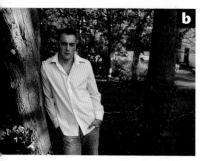

PERSPECTIVE

Perspective changes when the camera position is moved. This can be illustrated by keeping the subject the same size in the viewfinder and by altering the focal length of the lens as the camera is moved towards or away from the subject. As you move towards the subject the sense of depth between the foreground and background increases, while as you move away from the subject the apparent distance between foreground and background is compressed. This is true of all lenses but is particularly obvious when using long telephoto lenses at a great distance to compress foreground and background elements, or using a wideangle lens close to the subject and increasing the sense of depth.

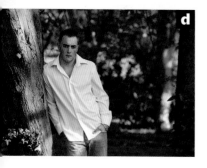

◄ *Shooting from different subject-to-camera distances can drastically alter the perspective of the image. This is illustrated here as I have moved the camera position away from the subject the perspective has been compressed, while I have used increasing focal lengths to keep the subject the same size in each frame.* **a)** *24mm,* **b)** *50mm,* **c)** *100mm,* **d)** *200mm.*

It's time to put into practice what I have been explaining, so here are some simple tasks to try out. I hope these exercises will make you think about which lens is the best choice in certain situations as well as being fun.

1 Grab the nearest family member and drag them into the garden or park. Stand far enough away to get them full length in the frame with a standard lens, take the picture, now take a stride towards them and shoot again. Repeat this until the camera cannot be focused because you are so close.

2 Now repeat this exercise with a range of lenses from wideangle to telephoto.

3 Remember to take a note of the focal length that you used to shoot each set of images.

4 Now compare your results by laying them in rows, or viewing them side by side on screen.

5 Select the images that look the most natural from each lens, then compare which one you would choose as the most effective lens at certain distances.

6 The results should jump out, with extreme wideangle shots being the most dramatic and with telephotos offering more natural-looking shots. Remember the results and apply what you have learnt when you get the chance.

TWO

43

EQUIPMENT

Tripods

A tripod is not an essential tool, but it can assist you, when photographing in darker locations that require slower shutter speeds and of course when faced with groups that require a narrow aperture for an increased depth of field; it helps to avoid camera shake in low-light locations indoors or out. Even the most basic tripod will allow you to set the camera height and position, which will allow you to leave the camera to walk back and forth to the group to adjust the pose or adjust a studio flash.

There are several types of tripod design and build quality. Try to buy a tripod that is not too heavy to carry around with you; if weight is a problem opt for a carbon-fibre model as they are about two-thirds lighter than metal tripods. The tripod should be able to take the weight of your heaviest camera, lens and flash combination. Auto-adjustment legs, using little pull triggers, are a luxury, but a great bonus when working fast and on location; locking legs will stop the tripod from falling over; and sealed tripod feet are great for wet locations such as the beach. If you plan to shoot low to the ground check how low the tripod will go – many of the more expensive models will drop almost flat.

▼ *There is a large selection of tripods available but try to buy the best you can, as it will probably outlast all your other equipment. The Calumet range of tripods, two of which are shown here, each have two extendible sections per leg to increase the height considerably. The larger model has a hook on the centre column to allow for weights to be used for extra stability, the smaller tripod allows the camera to be near to the ground if needed, by ratcheting the legs outwards.*

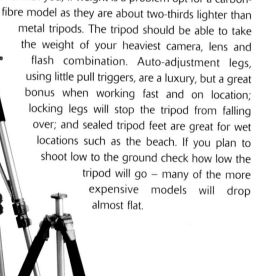

TRIPOD HEADS

There are three main types of tripod head: ball-and-socket, trigger-grip and pan-and-tilt. The ball-and-socket head is the most basic design with a single locking handle that when released allows the head to swivel around the ball, before being locked in place again. A version of the ball-and-socket head, the trigger-grip, is my favoured design; when its trigger is squeezed it allows the camera to swivel around the ball then locks the camera position when the grip is released.

The pan-and-tilt head is more flexible but more complex and therefore takes more time to use. It works on a two- or three-handle configuration: one to tilt the camera forwards and backwards, so the camera can point down or up; the second handle to tilt the camera side to side, to adjust the horizon; if a third handle is used it will swivel the camera left to right.

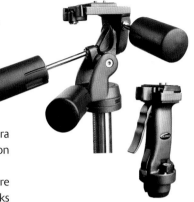

▲ *The pan-and-tilt and trigger-grip heads come with a quick-release plate to allow for a speedy transition between shooting handheld and using a tripod.*

QUICK-RELEASE PLATE

Most heads are fitted with a quick-release plate to allow the camera to be taken off and put back on the tripod quickly. The quick-release facility is excellent if, like me, you work most of the time handholding the camera for more candid images. However, look out for a model with a simple lock on the release, so you can't accidentally knock the camera off the tripod.

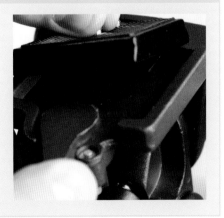

Flash

Portraits will take place at any time of day or night as well as different locations and so you cannot always rely on there being enough natural light, especially if you are shooting inside people's homes. So, to help illuminate the subjects, it is usually a good idea to have a small portable flash, known as a speedlight, or at least a built-in pop-up flash that you can turn to.

BUILT-IN POP-UP FLASH

A pop-up flash is a handy little accessory to have. Most compacts and amateur SLRs have one, although professional-spec SLRs may not. It is not a critical function of a camera as you can always invest in a more flexible and powerful external flash unit, but built-in flash still has its uses. Its limitations are its power and direction. The built-in flash is not very powerful, which limits how far the flash can travel and still illuminate the subject. The direction of the flash is fixed, meaning that you cannot bounce it from different surfaces and the subject may suffer from red-eye. However, the main use of a pop-up flash is to 'fill-in' shadow detail, which is useful when the subjects' backs are to the light source.

▼ *Pop-up flash is a great accessory, so much so that even some pro DSLRs have one.*

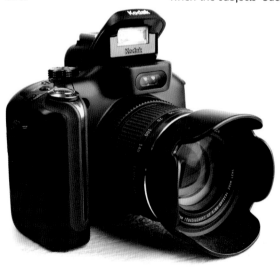

EXTERNAL SPEEDLIGHT FLASH

An external speedlight flash is simply an external flash unit that fits into the hotshoe of a camera. They are the most commonly used portable flash units due to their reliability, compact size, relative power and greater flexibility than built-in flashes. There is a wide range available at a variety of prices, meaning that cost need not be an issue. The power of a speedlight is enough to fully light a small group and it is controllable enough to use for lifting subtle shadow detail.

The technology in a speedlight flash is designed to operate in harmony with your camera, giving you a high degree of control over the power of the flash as well as its direction. You are normally able to swivel or tilt the flash head to provide different lighting effects. You can also fit diffusers to soften the effect of the flash and many speedlights have them built in.

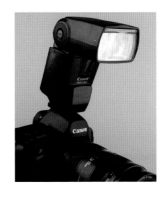

▲ *A speedlight is a small portable flash gun which sits on the hotshoe of an SLR or compact camera. It's an ideal starting point as well as a simple solution to illuminating a small family on location.*

DIFFUSERS

A simple way to soften direct flash from a speedlight is with a portable diffusion box, which will reduce the harshness of the light and soften specular highlights.

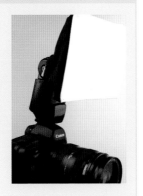

FLASH EXPOSURE

While you can control the basic exposure of an image for creative effect you can also change the output of the flash unit so that the subject is illuminated as you wish them to be. Depending on the camera and flash system that you have this level of output is either controlled via the flash unit itself or the camera body.

Controlling the output of the flash is known as flash exposure compensation. Varying the output allows you not only to ensure that you obtain the correct illumination of the subject (in conjunction with the basic exposure), but to apply creative effects to the image. As well as fine-tuning the flash output to balance the exposure you can use this function to create high-key or low-key shots (see pages 90–3). Typically a shot with a high degree of flash illumination looks a little more artificial and like a 'studio shot', while an image with a more subtle use of flash will look more natural. Neither is right or wrong, it just depends on the effect you are looking for.

Flash exposure bracketing is also an important tool allowing you to vary the exposure of the flash automatically in order to ensure that the effect you desire is achieved.

Multiple Speedlights

Linking two or more speedlights together can result in more professional-looking portraits and is very easy to do as the 'master' speedlight simply tells the other 'slave' speedlights when to fire. The speedlight on the hotshoe is usually the master and the slaves can be positioned where required and connected either via cable or infrared.

FLASH BATTERY PACKS

A speedlight has a fast recycle time with fresh batteries, but this can be increased dramatically with a supplementary battery power pack, such as those made by Quantum, which is attached via cable. This fast recycle time is perfect for more candid portraits, that's why there is always at least one power pack in my bag.

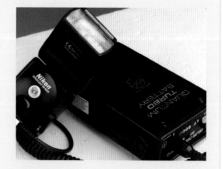

BOUNCE THE LIGHT

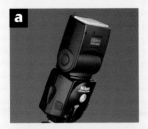

Most speedlights have tilt and swivel functions to allow the direction of the flash to be changed; the flash can be pointed to bounce off a wall or a ceiling. By bouncing the flash off a ceiling, a much softer-looking portrait will be achieved, due to the light travelling further and therefore spreading more than a direct flash; also there will be no harsh shadows behind the subject as the bounce spread will illuminate a little behind the subject and hide the shadow behind them.

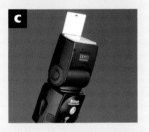

If you are working close to the subject, you can also bounce the flash off a key-light card which is usually attached to a speedlight with a swivel head. This key-light card pulls out from the top of the flash unit and is used to put a lovely 'catchlight' into the eyes of the subject, lifting the colour of the irises at the same time as illuminating the subject.

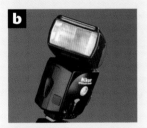

Gels can be added over the flash head to change the colour of the light output, which is a useful creative option.

TWO

49

EQUIPMENT

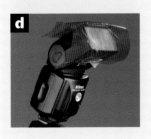

a) *Tilt facility to bounce light off the ceiling.*
b) *Swivel facility to bounce the flash off a wall or even a reflector.*
c) *The bounce card can be used to light a small group, but is designed to add a 'catchlight' into the eyes of an individual.*
d) *Coloured gels – either specially made or improvised – can be added to change the colour of the flash output.*

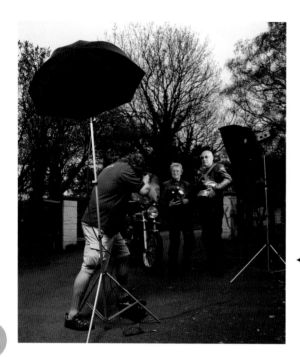

◀ *The Bowens Gemini studio flash systems can even be used on location thanks to a battery pack which can recharge the flash units in 4.5 seconds.*

STUDIO FLASH SYSTEMS

For a more professional portrait you can't beat a professional studio flash system as they not only give you a large quantity of very controllable illumination, but also a bright modelling light to see what the effect of the flash will be. There are different types of studio flash but a monobloc flash head, with the power control unit built into the head, is my preferred choice as its size and portability allows me to use it in the studio, in clients' homes or even on location when attached to a special battery pack.

How much power you need is the main decision when choosing a monobloc flash, but don't forget to consider its flexibility as well. A 500w monobloc, on full power, will allow you to photograph a large group with the light positioned at the same distance as the camera. The same monobloc has the ability to be turned down to 1/32nd power, positioned close and pointed directly at the subject and still shoot with a narrow aperture.

FLASH LIGHTING KITS

You will usually need a minimum of two studio flash heads to give more professional lighting to a portrait, one as the main light to light the subject and the other as a fill-in or background light. Good kits usually have two or three flash heads and come complete with lighting stands, a standard umbrella, a softbox and a carry case. The umbrella is used to bounce the light into, for a really soft, wide spread of light and the softbox is used to give a soft but more directional light source, all put together to make great family portraits easier.

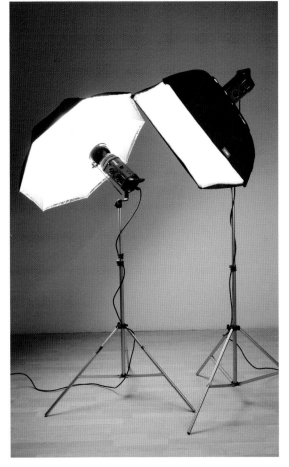

◀ *Portable studio flash kits help make taking the portrait easier and the end result more professional looking.*

The Perfect Set-up

For a perfect studio lighting set-up get four units all the same make and power. This will allow you to shoot any style of portrait as well as have accurate control and interchange accessories.

SOFTENING THE LIGHT

To produce professional-looking portraits you will have to soften the light for the majority of your images as direct flash gives a harsh look and exaggerates the subject's flaws such as lines and bags on the face as well creating unflattering lighting for facial features such as the nose. Softening the light is easily achieved with either a photographic umbrella or a softbox.

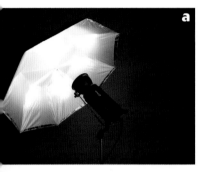

Umbrellas

A photographic umbrella is a cheap but effective light softener and very portable as it folds down. Different types of umbrella will allow you to soften the light in different ways, however, an umbrella will always spill the light due to its simple design. The flash can be either shot through a diffusion umbrella or reflected back from a standard umbrella. A directional umbrella is turned towards the subject to create more contrast. The most popular is a standard umbrella, which reflects the light back to the subject and gives a wide spread of light from its reflective interior.

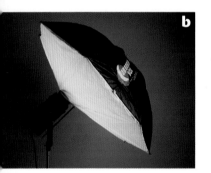

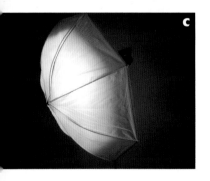

a) *A standard umbrella designed to efficiently reflect light. Good for groups.*
b) *A more contrasty light source good for individuals, couples and small groups for a more dramatic image.*
c) *A diffusion umbrella, which is a very soft light source, great for individuals and couples.*

Softboxes

A more expensive investment than an umbrella, but a softbox will produce the better softening due to its design and control of the light. It can still be used to light groups, but it takes a little more practice to get perfect results. The softbox produces very natural-looking light with plenty of subtleties, almost like light from a window when positioned very close to the subject. It also produces nice catchlights in the shape of the softbox.

The softbox is made up of many layers of a heat-resistant material, which diffuses and softens the light source from both the modelling bulb and the flash, allowing the softbox to be used at close quarters. Choose a softbox with at least two layers of diffusion to provide the best results.

As your lighting skills improve look at the different variety and shapes of softbox as they are all designed to do different things.

Softbox Sizes

A 24in (60cm) softbox is used for head-and-shoulder portraits. A 40in (100cm) softbox is the most popular for general use. A 70in (175cm) softbox is a fantastic broad light source for large groups.

◀ A softbox is made up of a flash bulb surrounded by reflective material and covered by a diffuser.

▼ Different shapes and sizes of softbox are available for a wide variety of different applications.

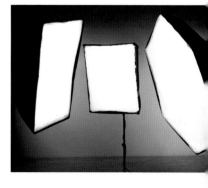

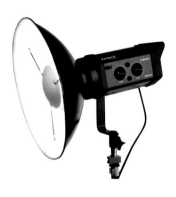

STUDIO FLASH ACCESSORIES

Your choice of studio lighting should take into account future creative use of the light, as control of the light is a key if you want to take fine-art portraits of your family. Most creative lighting techniques and effects are easily achieved with simple accessories that attach to the front of the flash heads to completely change the shape of the flash and the modelling light.

When using these accessories on your studio flash heads, you will start to see the use of harsher light due to the lack of any diffusion between the flash and the subject. Your portraiture will instantly look more creative, but your skills with flash will now have to be fine-tuned as there is no way of covering up any bad lighting techniques, because any mistakes are amplified by the harsher light cast on the subject.

▲ *A parabolic flash head has a unique quality in being able to soften the light but also bring sharpness to the portrait.*

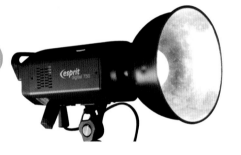

▲ *The highly polished interior of the reflector dish produces a hot spot and harsh shadows very similar to sunlight.*

▼ *Barn doors open and close to control the spillage of light onto the background as well as creating different effects for the subject.*

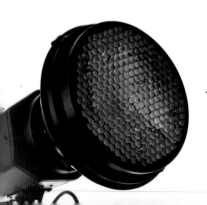

◀ *The honeycomb attachment will control the light spillage allowing the light to only travel in a straight line. It produces a sharper light with greater control.*

▼ The snoot attachment is mainly used to light the hair, giving concentrated light as well as a soft out-of-focus spotlight effect.

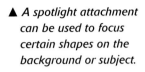

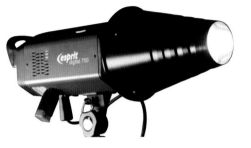

▲ A spotlight attachment can be used to focus certain shapes on the background or subject.

◄ The colour of the light can be changed by simply adding coloured gels with double clips.

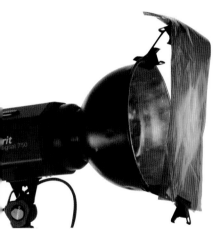

Metering Studio Lights

When setting your studio flash measure each monobloc unit independently, to get a more accurate reading.

▼ Gobos are used in conjunction with a spotlight attachment and are available in a large variety of styles.

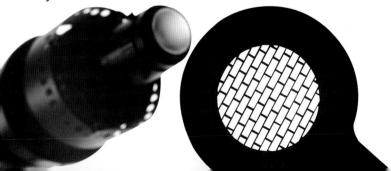

REFLECTORS

A reflector is a 'must have' for any portrait photographer as its simple ability to reflect or diffuse light makes it the perfect tool to enhance subjects by either adding, or occasionally subtracting, natural light or flash.

A reflector can be as simple as a piece of white card or a white wall. I use fold-away Lastolite reflectors as they are quick to open and compact when stored; I use a range of different styles, sizes, colours and reflective materials for different effects. On a cloudy day I use a silver or 'sunlight' reflector as this will sharpen and slightly warm the light. This same reflector can be used on sunny days but because of the mirror-like surface a harsh light will be directed onto the subject for a more dramatic image.

If working alone a 'tri-grip' reflector is easy to use; it can be held in one hand to direct the light without the need for stands or supports.

If you want a soft, natural look to your portrait when the sun is directly falling onto the subject, use a large diffusion reflector placed between the subject and the sun; this will soften the harsh light as well as helping prevent the subject squinting.

Black 'Reflectors'

In some circumstances a black 'reflector' can be used to deaden and remove the light from one side, this is called subtractive lighting. The technique will also increase the modelling on the face if the lighting is soft with no specular highlights.

▼ *A diffusion screen used to diffuse harsh sunlight or off-camera flash.*

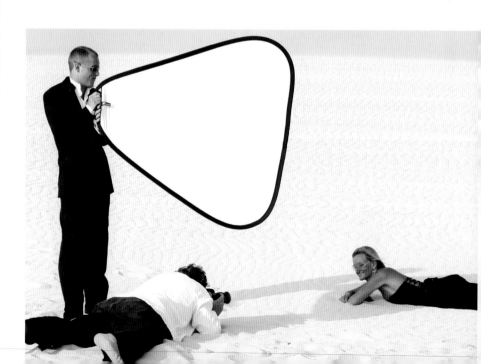

▲ *A wide range of reflector colours is available.*

REFLECTORS FOR DIFFERENT EFFECTS

✔ **White** – for very sunny climates when a soft reflection is needed.

✔ **Gold** – to give an exaggerated warm feeling.

✔ **Silver** – to give a mirrorlike reflectance.

✔ **Sunlight** – a slightly warm glow.

✔ **'Sun fire'** – warm light specular highlights.

✔ **Black** – to subtract light and to create modelling.

✔ **Tri-grip** – if you are working alone try a new easy-hold reflector (a reflector with a handle).

Film and Digital Formats

Aspect Ratio

The shape of a format is described by the ratio between its width and its height – its aspect ratio. The most common example is the aspect ratio of 35mm film, or the sensors used on most Dslrs, which is 3:2.

There are many different film and digital formats available at the moment, so here are some of the more popular ones.

35mm film

The 35mm film format is the most popular for amateur photographers, especially for more informal portraiture shot in black & white. Its frame measures 36x24mm, but the small negative or transparency means that there are limits to enlargement, as the size of the grain is more apparent when heavily enlarged and there is also some loss in sharpness. However it's really cheap to buy, process and print, as well as being easy to store.

645 film

The 645 format is the smallest of the medium formats, it uses 120 rollfilm and provides a frame of approximately 56x41.5mm. The 645 format is a stepping stone from 35mm film to the larger medium formats and has the benefit of already being slightly squarer format with a 4:3 aspect ratio which is useful for groups.

6x6 film

The 6x6 format is the square format, again it uses 120 rollfilm and is actually closer to 56x56mm. It was the most popular film format with portrait photographers before digital technology began to dominate.

6x7 film

The 6x7 format uses 120 rollfilm to produce an image of 69.5x56mm. It is sometimes referred to as the ideal format, but this only refers to the similar ratio between it and some US paper sizes. Due to the large size of the format the negative does allow for bigger enlargements to be made before any loss of quality from visible grain or loss of sharpness is apparent.

Digital compacts

The sensors of digital compacts vary in size. They tend to be very small with approximately 7.2x5.3mm (1/1.8in) and 5.8x4.3mm (1/2.5in) being common sizes. However, most use the 4:3 aspect ratio, which is the aspect ratio of many computer monitors.

Digital SLRs

Most DSLRs' sensors replicate the 3:2 aspect ratio of the 35mm frame and can be split into two groups, full-frame and cropped sensors. A full-frame sensor equals the size of a 35mm frame but a cropped sensor (or APS-C sensor) is normally around 24x16mm, which means that the effective focal length of a lens will be multiplied by around 1.5x when compared to the same focal length used on a 35mm film or full-frame SLR. The exception to the 3:2 aspect ratio is the FourThirds system, an open standard supported by Olympus, Panasonic and Leica, among others, with a sensor size of 18x13.5mm and, as the name suggests, a 4:3 aspect ratio.

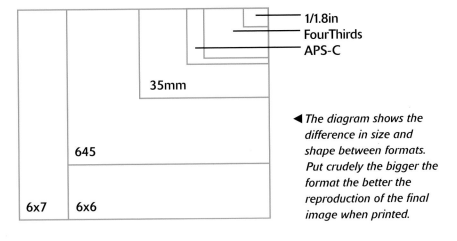

1/1.8in
FourThirds
APS-C

35mm

645

6x7 6x6

◀ *The diagram shows the difference in size and shape between formats. Put crudely the bigger the format the better the reproduction of the final image when printed.*

Film

Film Types

When using film you can choose a different film for different lighting conditions such as tungsten- or daylight-balanced film, but most portrait photographers use daylight-balanced negative film even when working inside and have the lab make any slight corrections at the printing stage.

Film choice is vast but mainly breaks down into two types, negative and transparency. Each of these film types is available in a variety of ISO ratings (which represent its sensitivity to light) and is available in two main sizes of film: 35mm format for SLRs and 120 for medium-format cameras.

Portrait photographers who still shoot film mainly choose to use a negative film. This is still due to printing costs at the photo lab, as the cost is considerably cheaper than printing from a transparency. A negative is also more forgiving of any mistakes in exposure or colour balance, as these can have slight corrections made to them at the printing stage in the lab.

Contrast in a colour portrait has always been controlled in the lighting of the subject, as there was no real adjustment in the printing stage before scanning became popular, unlike black & white film of course where there has always been the ability to change the portrait's contrast through using different grades of paper or filters in the enlarger.

▶Black & white film in both 35mm and 120 format from Ilford, one of the leading manufacturers of traditional materials.

Digital Sensors and Buffers

Digital sensors are made up of pixels, a combination of light-sensitive photodiodes and their associated electrical arrays. The number of pixels is the resolution of the image, in other words how much detail it contains, while the individual pixel size determines, to a certain degree at least, the quality of the image.

Many digital compacts boast a high resolution but because their sensors are smaller, the pixels are smaller, which leads to the image quality being poorer due to increased noise (see pages 80–1) and the more restrictive limits of the dynamic colour range (the range from shadow to highlight without losing detail).

The sensors used in cropped-sensor DSLRs are obviously smaller than full-frame DSLRs, but larger than those of compact cameras, therefore both the resolution that they offer and the size of the individual pixels tend to be between these points. Full-frame sensors offer both higher quality and higher resolution, although they are less forgiving of poor-quality lenses.

Once the image is captured by the sensor it is processed in the buffer. This is where the raw information provided by each pixel has any image

Raw

Shooting in raw format will allow you to quickly adjust colour and exposure in the raw software on the computer before processing the file to become a tiff or jpeg.

▼ *The DIGIC II processor used in Canon's EOS 350D / Digital Rebel XT.*

TWO

61

EQUIPMENT

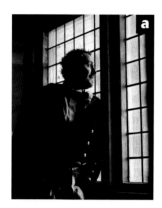

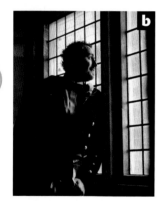

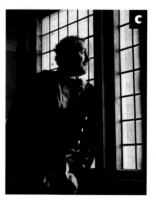

parameters – including sharpness, saturation, hue, contrast and white balance – applied to it. If the image is shot as a jpeg or a tiff then these parameters will be embedded within the file. However, if the image is shot as a raw file it will include all this information attached to the file. This means that it can be altered simply and easily in the raw-processing software on computer. However, raw files need this processing; without it they cannot be easily read.

White balance (WB)

Different light sources emit light in subtly different colours; your eye compensates for this naturally, but with film cameras you need to use filters or use specially balanced film. Digital cameras allow the photographer to change the white balance on camera to suit the lighting conditions. Cameras have an automatic white balance function where the camera estimates the correct colour balance; this is normally accurate outdoors, but can become erratic indoors or with mixed light sources.

The secret to simple colour balance is to keep all the images to a similar tone and not allow the camera's settings to deviate slightly between each image. This is simple to achieve if you shoot raw files and set a preset white balance as all the images in post production can be corrected by a choosing the white-balance picker and simply selecting something grey or almost white.

◀ *The same shot shown with different white balance settings applied in the raw-processing software.*
a) *auto,* **b)** *flash,* **c)** *tungsten.*

Memory Cards

Just like film there are different types and sizes of memory cards and which you use depends on the camera requirements. They come in different storage sizes, from 256MB to 8GB, and also in different read/write speeds, which determine how fast the image transfers from camera to card and card to computer.

CompactFlash cards
CompactFlash cards, known as CF cards are the DSLR standard, due to their reliability and large storage capacity to cope with the very large raw file sizes created. CF cards have kept pace with the demands of the DSLR and are now reasonable value.

Microdrives
Microdrives were first developed by IBM and are in essence very small hard disks, which initially made them cheaper per megabyte than CompactFlash cards but also more prone to damage. The spinning drive in a microdrive typically uses more battery power because of moving parts and creates more heat which results in more image noise.

SD cards
Secure digital cards are physically small, but now boast increasingly large capacities. The cards are used in larger compact cameras and some amateur DSLRs and have a write-protection switch on the side like a floppy disk has.

Other cards
Various other cards are available for compact cameras, such as the xD format championed by Olympus and Fujifilm and the Memory Stick produced by Sony. The one you use will be determined by the camera that you use.

>> **SEE ALSO**
Raw versus jpeg, page 82

▼ *Manufacturers such as Lexar produce ranges of different format cards with differing capacities and read/write speeds.*

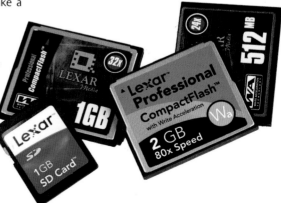

TWO

63

EQUIPMENT

THREE **TECHNIQUE**

Having a good understanding of the basic techniques is the cornerstone of improving your photography. Once you understand exactly how your camera is working and how to control it you can then start to exert creative influence over your images and they will improve no end.

Focusing

While using manual focus will give you more control, most cameras still offer an in-camera confirmation light for you to check when focus is achieved.

Portraits, as a rule, will require sharpness of focus on the subject, especially their eyes and if the portrait is of a group all the eyes should be pin sharp unless left intentionally soft for creative reasons. So, understanding focus and controlling the point of focus in a portrait will make or break an image.

As a lens can only focus on one point, or should I say on one plane, then technically everything in front and everything beyond this point is out of focus. So if a subject is a certain distance away and you focus on them, then this is the point and plane of focus; a subject in front or behind can only be made to look like they are in focus by managing the available depth of field.

Depth of field is a term that indicates how much of the image, from foreground to background around the point of focus, appears to be in focus in the final image.

The depth of field available is determined by a combination of aperture, focal length and subject-to-camera distance. All three of these need to be controlled to give the appropriate depth of field in a family photograph, particularly for groups where the person at the back should appear as sharp as those at the front.

Aperture is the main tool for controlling depth of field in a family snap. A wide aperture (a low f-number) will give a shallow depth of field, suitable for throwing the backgrounds of portraits out of focus, while a narrow aperture (a high f-number) while give a greater depth of field, useful for making sure that whole groups are sharp from front to back.

The focal length of the lens will also be a factor in determining the depth of field. The shorter the focal length the greater the depth of field and the longer the lens the less depth of field is available. Obviously other factors will also affect your choice of focal length, but telephotos are generally used for portraits with a shallow depth of field while wideangles are better suited to group shots not just because of their angle of view, but also because they afford more depth of field.

The distance between the camera and the subject is another factor, as the closer you are to the subject the less depth of field will be available for a given lens and aperture combination. However, most photographers like to work as close as possible to their subjects to maintain eye contact and conversation, so this puts more emphasis on aperture and lens choice.

MANUAL FOCUS

Many autofocus cameras allow you to switch autofocus off to allow you to focus manually when autofocus struggles. Manual focus is slower than autofocus, but often more accurate for the family photographer, especially when there is less chance of subjects moving.

Manual focus is really useful for portraits where the subjects are still and you do not have to change focus quickly. However, it is hard to keep up with fast-moving subjects such as children playing so autofocus may be more suitable.

▼ *Most SLR lenses will allow you to swap between autofocus and manual focus on the lens barrel.*

▼ *In low-light situations autofocus systems will often fail to work. This is when it is best to switch to manual focus.*

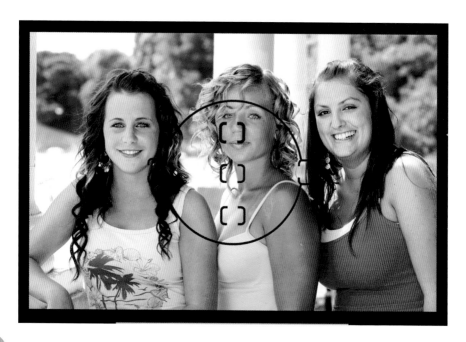

▲ *In the viewfinder there are often multiple autofocus points; these can either be chosen manually by the photographer or automatically by the camera.*

Low Light

Autofocus can struggle in low-light conditions and when subjects have low contrast, so be prepared to use the manual focus facility on the lens if available.

AUTOFOCUS

Shooting from the hip, as they say, is simple with autofocus as the lens locks onto the subject when you semi-depress the shutter-release button.

Most cameras that have autofocus – compacts and SLRs alike – depend on contrast to tell the camera and lens when the image is in focus and a motor in the lens sets the correct focal distance to give a sharp subject.

Many cameras offer two types of autofocus mode: single shot and continuous. The single-shot mode will focus and hold its focus when the shutter-release button is semi-depressed, while continuous mode will keep adjusting the focus until the shutter is released. This means that single-shot mode is more suitable for stationary subjects while continuous mode is better for moving subjects.

Many cameras offer different autofocus points you can set, to allow you to focus off-centre. These should help you be more creative with your compositions, and while the camera can be left to select these itself you should confirm that focus is on the right point.

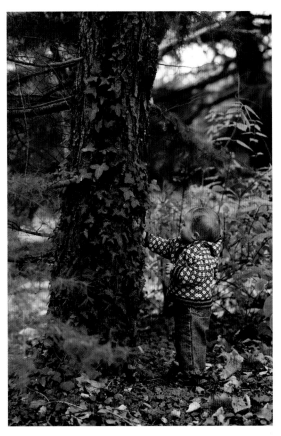

◄ *When the main subject is well defined or in the centre of the frame the camera obtains perfect focus almost every time.*

▼ *If the camera is challenged with prominent foregrounds it can find it difficult to focus unless a focus point is selected manually.*

Learn how to...

FOCUS OFF-CENTRE

If you want to shoot with the subject composed outside the autofocus array then point the camera at the subject, now semi-depress the shutter-release button and reposition the camera for a new composition before finally taking the picture. If you release the shutter-release button before taking the picture you will have to start over again.

Depth of Field

A s touched on earlier the depth of field controls the amount of the image that appears sharp; it is achieved by a combination of the chosen aperture, the focal length of the lens used and the camera-to-subject distance. All three of these give the relevant depth of field in an image.

For my portraits the first point of depth of field control in is controlling the actual depth of the subject, for example the depth of a group; if you can keep this distance shallow less depth of field is required when focusing on a subject in the middle.

Lens selection is the next key control of depth of field, as the longer the lens used the shallower the depth of field, especially when working close to the subject, as is popular when taking portraits.

Aperture is only the third in my list of priorities as you can retain control over the aperture and therefore depth of field by using flash.

Camera-to-subject distance is usually under my control, so this is the last part for my depth of field control equation, as the closer I am to the subject the shallower the depth of field will be.

▼ *This picture demonstrates a shallow depth of field with the flowers pin sharp, the subject out of focus and the background fully blurred.*

✔ **Individuals**

A three-quarter-length portrait is usually shot on a standard lens on an SLR camera as previously explained. An aperture of f/2.8 would be enough to keep the eyes to nose sharp, but beyond that would be soft due to a lack of depth of field. An aperture of f/8 would keep all of the torso sharp, especially when one shoulder is pointed towards the camera. However, if a longer lens such as a 135mm telephoto was used, even with the camera moved further back to re-frame, an aperture of f/8 would struggle to keep the whole body sharp.

✔ **Couples**

When photographing couples it is best to use an aperture of between f/5.6 and f/11 to maintain a workable depth of field. As you can see to the right the boy is very out of focus even though only a little way behind his parents. This is due to a short telephoto being used at a relatively small distance.

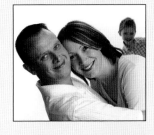

✔ **Groups**

For maximum depth of field, a wideangle lens, with a small aperture of say f/22 and a camera-to-subject distance of around 20ft (6m), will keep all of the subjects in a big group sharp. For smaller groups you can normally get away with an aperture of around f/11 to maintain sharpness from front to rear.

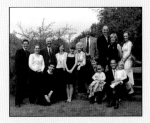

Exposure

▲ *A sequence showing an underexposed, correctly exposed and overexposed image.*

orrect exposure is the key to getting detail in all of an image; any under- or overexposure will result in less detail and a significant loss in quality in the final photograph, even with some digital correction. Exposure can be set automatically with most cameras but when you want to control fine detail in an image you will have to look to more advanced compacts and preferably SLRs and DSLRs where you can control exposure.

While modern autoexposure systems are fairly sophisticated and get most shots spot on, they can be fooled by difficult subjects. Correct exposure is based on the concept of mid-tone, which is a neutral tone that reflects 18 per cent of the light falling on it. Put crudely most autoexposure systems assume that the majority of the frame is mid-tone and will expose the image to record it as such. The most common cause of error is that the subject is in fact not mid-tone: if it is significantly lighter than mid-tone then the camera will underexpose it, while if the subject is significantly darker than mid-tone the camera will overexpose it.

Underexposed images will appear muddy with little contrast and very little detail in the shadow areas. Overexposed images will lose detail in the highlights and tend to have a very high contrast. With digital photographs this can be particularly unattractive with white highlight blotches on the finished image.

The exposure is changed on the camera in half, third or full stops by either altering the shutter speed or the aperture. If the image looks too dark the shutter speed should be lowered or the aperture has to be opened up to a lower f-number. If the image is too bright the shutter speed should be increased or the aperture has to be closed down to a higher f-number.

Metering

To make full use of your camera and its technology, it is essential to get to grips with understanding the in-camera metering settings, especially for an SLR and a DSLR. Don't by frightened of the metering options as these functions are there to help you take great pictures and get the best exposure.

Multi-segment

Is the most advanced of the metering options, as it takes multiple readings across the image and combines them for one reading. It's an ideal setting when you have to just point and shoot as the multiple readings will allow more for large areas of dark and light, but you have less control and the metering can still be fooled by high-contrast situations.

Centre-weighted

Takes multiple meter readings across the image but gives emphasis to the centre of the image, which makes it good for a close group shot. The results are more predictable than the multi-segment metering and it is easier to use than spot metering. It is still necessary to take care with large light and dark areas, as the meter can still be fooled.

Spot

Spot meter readings are the best if you can fill the small spot, normally under the central or active autofocus point, in the camera with a mid-tone subject area, as the meter will take its exposure from only this spot. This makes it ideal for portraiture as it will ignore bright and dark areas around the subject. In a pro camera you can choose from a variety of different spots, which makes it easier for you to compose the subject and expose it accurately at the same time.

▲ *Multi-segment metering systems use a pattern to calculate the correct exposure taking into account the whole scene.*

▲ *Centre-weighted metering systems take information from the whole scene but weight the calculation towards the central portion of the frame.*

▲ *Spot metering systems assess the level of brightness from a small area of the frame.*

HANDHELD METERS

A handheld light meter is still used by most professional photographers to get accurate flash and ambient exposure readings. A perfect exposure will record all the detail from the shadows to the highlights, which will result in accurate tones throughout the image.

For the best ambient or flash metering, position the meter close to the subject's face and point the meter towards the light source to get the correct incident light reading. Use this technique especially for studio flash, as the camera's aperture has to be set manually with the exposure given. The meter will give the required aperture and shutter speed to set on the camera.

▼ *A handheld light meter will measure ambient and flash light accurately; it also has different accessories to record spot, incident and reflective meter readings.*

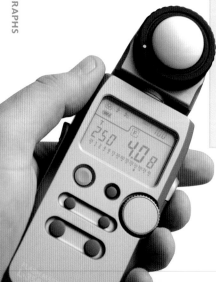

LIGHT METER ATTACHMENTS

A handheld meter has three different attachments to take an exposure.

Incident
A flat or domed white disc, to take a meter reading towards the light source or camera.

Viewfinder five degree
To take a spot metered reading by targeting the meter via the viewfinder attachment.

Reflective
A black disc with a hole, to take a reflected reading by pointing the meter at the subject from the camera.

HOW A METER WORKS

Reflected-light meters, including through-the-lens (TTL) in-camera meters, are calibrated to read for the average mid-tone, which is 18 per cent of the reflected light of the subject. In principle the meter is trying to set an average exposure over the whole portrait so the image can have shadows and highlights with detail. This is great for the majority of subjects, however, not all subjects are mid-tone and when confronted with a subject that isn't mid-tone it can cause problems. This isn't a problem for handheld incident meters as they read the light direct from its source, rather than reflected from the subject.

A camera can easily be fooled into the wrong exposure if the subject or a large part of an image is significantly lighter or darker than mid-tone. Shots that include a large amount of sky, sunlit sand or even a white wall can be underexposed as the meter tries to render them the mid-tone that it assumes they are. This will make the subject look darker than it is with little detail in the shadow areas.

A similar problem will happen, but in reverse, with a very dark subject or location, such as at night or in a dark room setting, as the camera will attempt to overexpose the image in order to render the subject mid-tone.

With an incident meter the task of taking an accurate exposure reading is simple, as you can position and direct the meter towards the light source, which will then give a reading that is unaffected by the tone of the subject or the location.

With a reflected-light meter, including TTL meters, you simply have to ensure that the part of the frame that you are metering from is roughly mid-tone. This is putting it slightly crudely as many camera meters are far more sophisticated than this; however, they still base their readings around the concept of mid-tone.

▲ *Hold an incident meter near to the subject's face and pointed slightly towards the light source.*

Off-centre Exposure

If you want to compose the subject on one side of the frame, but your camera's focus points do not cover the area, first compose the subject in the sensor and press the automatic exposure lock (AE-L) button before recomposing and taking the shot.

Exposure

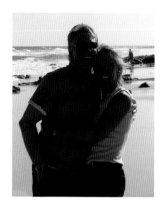

▲ *If your camera has no override or special settings the subjects will often be underexposed when faced with a bright background.*

▼ *Another quick fix if you cannot override the camera is to add fill-in flash or, better still, a reflector.*

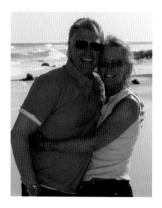

Today's technology is allowing the photographer to get lazy if they wish because the cameras are quickly coming up with simple-to-use functions to make sure you obtain better results. However, a good technical and creative understanding of exposure is vital if you are to take your photography to the next level.

The exposure equation takes into account shutter speed, the aperture and the ISO rating of the film or sensor. In low-light conditions slower shutter speeds, wider apertures and higher ISO ratings will all allow you to take a correctly exposed image; while in bright conditions narrow apertures, faster shutter speeds and lower ISO ratings may all be required.

The relationship between the three is very simple as an increase in one variable can be compensated for by an equal but opposite change in another. This is known as the law of reciprocity, and this ability to change individual variables without altering the overall exposure enables you not just to use the exposure variables to obtain a correct exposure but also to apply creative effects that will be explained on later pages.

When it comes to controlling exposure you really need control of the exposure variables, which means being able to change the shutter speed and the aperture. While many cameras include set modes for the most common scenes such as snow/beach and portraits at night, these offer you no real control so you are better off using the aperture-priority (where you control the aperture and the camera sets the shutter speed), shutter-speed priority (where you control the shutter speed and the camera sets the aperture) and manual mode (where you control both aperture and shutter speed).

Bracketing

Another way of ensuring the correct exposure is bracketing the exposure; this can either be done automatically by some cameras or manually, if the camera will allow you. The practice of bracketing is more common with film cameras than digital, as digital technologies allow you to review the image straight away, whereas with film you don't know if the exposure is wrong until it's back from processing. Portrait photographers rarely use bracketing as time and care is usually taken for a correct exposure in setting up so we can concentrate on the right expression and not worry about losing the shot due to a wrong exposure. However, it can be useful in family situations when it is quicker to take a burst of images than it is to spend time making sure the exposure is spot on in the first place.

Bracketing is achieved by shooting what you think is the right exposure then one or two exposures on either side at predetermined intervals. This results in a sequence of shots at different exposures from which you can choose the best. This a very slow technique when done manually by changing the aperture or speed, but when the camera does the bracketing automatically it is complete in a matter of seconds.

▲ *This shows the Canon EOS 5D's facility to bracket by up to two full stops.*

Bracketing Tip

When metering for digital it is better to slightly underexpose the image to retain detail in the highlights.

▼ *A bracketing sequence showing* **a)** *overexposed,* **b)** *correct exposure and* **c)** *underexposed.*

Aperture

f-NUMBER INDEX
f/1.4
f/2
f/2.8
f/4
f/5.6
f/8
f/11
f/16
f/22
f/32
f/45

The aperture controls the amount of light let through the lens and into the camera. Inside the lens is a circle of blades, known as the aperture iris, that open and close, just like the human eye's iris opens and closes the pupil to let through more or less light. The different sizes of the aperture are measured in f-numbers, these show the size of the aperture as a proportion of the focal length of the lens; for example, f/2 means that the diameter of the aperture is half the focal length. This means that the lower the f-number the wider the aperture, and vice versa. The sequence of whole f-stops (not fractions of a stop) is shown on the left; each step down the list means a halving of the light transmitted, while each step up means it doubles.

As mentioned earlier (see page 74) the aperture is used to balance the overall exposure equation, but also to determine the depth of field in conjunction with the focal length of the lens and subject-to-camera distance.

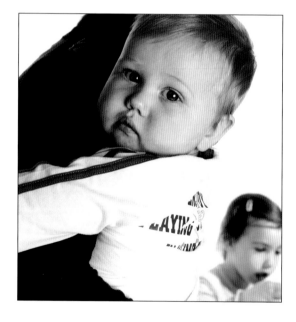

▶ The aperture controls the depth of field, therefore the amount of the image that appears sharp from foreground to background.

Learn how to...

CONTROL THE EFFECT OF APERTURE

While depth of field varies with other factors, as discussed on page 68, here are a few rules of thumb for using the aperture creatively:

f/2.8 makes it very easy to throw out the focus of the background or foreground; it also allows you to shoot in low-light conditions. When focusing close-up, the point of focus is critical as this aperture gives little depth of field.

f/5.6 is a general aperture for portraiture as it is wide enough to give a good depth of field for a three-quarter-length portrait when using a standard lens. When using a longer focal length it will give a limited depth of field, but is still adequate for most individual portraits. The aperture is still wide enough to work in low-light conditions and to handhold the camera depending on your ISO.

f/11 is ideal for groups when using a wideangle to standard lens. When shooting a small group with a short telephoto lens, the depth of field is shallower helping the background to go out of focus. The camera can be handheld still on sunny days or with studio flash.

f/22 is only used when you need as much depth of field as possible or on really sunny days. This aperture gives a large depth of field with a wideangle lens, so is perfect for large groups or when trying to maintain detail in the background or foreground.

▲ *Setting the aperture via the camera is usually done by turning a command dial.*

<< **SEE ALSO**
Depth of field, page 68

THREE

77

TECHNIQUE

Fast Lenses

A lens with a very wide aperture such as f/1.8 is referred to as being fast, as it allows faster shutter speeds to be used in low light.

Shutter Speed

Avoiding Camera Shake

The shutter speed should at least equal the focal length of the lens when handholding to keep things sharp; for example a 100mm lens = 1/100sec.

The shutter speed refers to the amount of time the shutter is left open to gain the correct exposure; it also exerts control over how movement is depicted. Faster shutter speeds will freeze motion, while slower shutter speeds will allow it to blur, depending on how fast the subject is moving.

Basically, for a correct exposure in low light conditions or with a narrow aperture, the shutter will need to be left open longer. In bright sunny conditions or with a wide aperture on the lens the shutter needs only to be open for a short length of time. Every doubling of a shutter speed means that half as much light is admitted, this sequence is shown opposite.

The shutter speed can also be used for creative effect, not just to control the exposure. Slow shutter speeds are ideal for more creative portraits especially when combining them with small amounts of flash on the subject; this is often referred to as dragging the shutter. You will need to support the camera on a tripod to keep image blur from camera shake to a minimum and it's also wise to invest into a cable release so as not to move the camera when pressing the shutter-release button as you take the shot.

One second is a very slow shutter speed for photographs of people, as the subject only has to move a fraction to become blurred, generally this and slower shutter speeds are not recommended, although flash can be used if necessary.

◀ *Use a fast shutter speed to freeze motion; also practise panning – following the subject through the lens with a slightly slower shutter speed to blur the background but keep the subject sharp.*

Slightly faster shutter speeds such as 1/15sec are ideal to use indoors, as the ambient lighting can add to the overall effect by lighting the background and giving a warm tone overall. At this speed any movement from the subject will be very blurred. You should still support the camera with a tripod to avoid any camera shake, but with some practice of a wider foot stance and relaxed breathing you should be able to handhold the camera in an emergency; also, propping yourself against a wall or using a tabletop to rest on will also help.

Faster still, a shutter speed around 1/60sec is a good place to start handholding the camera with a standard lens; it is quick enough to avoid most camera shake as well as freeze any slight movement from the subject. It's a good shutter speed to use with flash as it allows the subject to be lit more subtly on duller days. While faster yet at around 1/125sec should result in no camera shake and freeze moving subjects, such as children playing.

At around 1/250sec you can try to keep the aperture wide to control depth of field as well as freeze movement on a sunny day. However, it should be noted that some cameras do not synchronize with flash at this speed or above, which will result in a part of the image not being exposed to the flash if used.

A shutter speed of around 1/1,000sec will freeze almost all subject movement, even running shots. While most SLRs and DSLRs offer much higher shutter speeds up to around 1/4,000sec and sometimes beyond.

SHUTTER SPEEDS

| 30 seconds |
| 15 seconds |
| 8 seconds |
| 4 seconds |
| 2 seconds |
| 1 second |
| 1/2sec |
| 1/4sec |
| 1/8sec |
| 1/15sec |
| 1/30sec |
| 1/60sec |
| 1/125sec |
| 1/250sec |
| 1/500sec |
| 1/1,000sec |
| 1/2,000sec |
| 1/4,000sec |
| 1/8,000sec |
| 1/16,000sec |

Room Lights

When photographing in a home with flash, use 1/15sec to allow the room lights to glow and illuminate the background.

ISO

▲ *Higher ISO ratings, such as ISO 800 used here, give more atmosphere.*

ISO Test

Test each setting on your camera and know its practical limits; look for the noise, which is most visible in smooth-toned areas such as sky.

Different levels of light demand different sensitivities of your camera equipment, both film and digital. When using film you have to choose the right film speed for the conditions, but if those conditions change drastically midway through a portrait, you might find yourself wasting the end of a roll due to having to change to a higher or lower ISO film. Now with digital cameras you can just change the sensitivity of the sensor at any time, allowing you to compensate for changing light simply and quickly.

ISO does not only represent the sensitivity, it also gives an indication of its quality. A lower ISO will give you smaller film grain and less noise in a digital image as well as a greater saturation of colour compared to fast ISOs which give large amounts of grain and noise as well as more muted colours.

Assessing the conditions is the secret to which speed film or digital ISO rating to use, for instance a portrait taken with flash or sunlight will need a maximum ISO of 200, which will allow a wider aperture for less depth of field. If the location is dark you will need a faster ISO, such as 400 or 800, to get correct exposure; but remember the faster the ISO the more grain or noise will be visible in the final image.

▶ *Low ISO ratings make for smoother, more pleasant skin tones.*

ISO 100

To get the best results use the lowest standard ISO setting, on digital cameras this is often 100. This will give smooth tones and little noise, especially when shot in raw.

ISO 400

On most cameras ISO 400 is going to be your limit if you want to maintain quality. The higher ISO will allow you to shoot in worse light, but you will see a slight increase in film grain or digital noise.

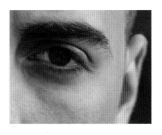

▲ *ISO 100.*

ISO 800

High ISO settings will start to make grain and noise a bigger issue as you don't have to look too hard at the print to see the granular texture in smooth-toned areas.

ISO 1600

On some pro DSLRs this still gives acceptable results, however, the visible coloured dots of digital noise and film grain on the image are an issue, but you will be able to shoot in very low light conditions without flash.

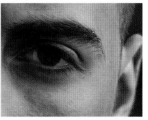

▲ *ISO 400.*

SOME USEFUL HINTS FOR ISOs

ISO 100 for bright, sunny days and portraits lit by studio flash.
ISO 200 for general use with some flash if it is required.
ISO 400 for duller days and some bright interiors.
ISO 800 for dark locations when you don't want to use any flash.
ISO 1600 for really dark locations and an emergency.

▲ *ISO 800.*

▲ *ISO 1600.*

Raw versus Jpeg

A digital file format is how the image is stored on the card after shooting and the main two types are raw and jpeg.

Raw files allow more effective post-processing on computer, particularly to fine-tune exposure and colour. The exposure of a raw file can be corrected by up to two stops either side of the starting exposure. The white balance can be corrected or altered to suit your tastes, which is very useful with large numbers of similar pictures, like groups shot on location, where colour can fluctuate slightly between shots. When altered the raw file then must be converted to a tiff or a jpeg file, before it can be used in other software and printed. The main disadvantage is that a raw file is larger than a jpeg, so the number of images that are able to be stored on the digital card is greatly reduced. This post-processing is also necessary rather than optional as raw files can look flatter than jpegs unless they receive the appropriate fine-tuning.

Jpegs are the most common image file type and they are suitable for use straight from the camera either in software such as Photoshop or when being sent directly to a printer. A jpeg, unlike a raw file, is a compressed file; this makes the file much smaller than a raw file, but there is some loss of quality. This is only tiny, particularly with high-resolution cameras, but if you want perfection then a raw file is the way to go. A jpeg itself can be stored at different qualities and compressions so you can choose a file size and compression to fit your needs.

Tiff is a lossless file format that is often used by professionals to maintain the quality of the image at all times. Some digital compacts allow you to shoot in tiff format, but it is generally used on computer when converting a raw file into a more readily usable format. Tiff files are even larger than raw files so storage on your computer can soon become a problem.

▼ *This camera screen shot shows the different quality settings available on a digital SLR. It also shows the different file types and sizes available.*

It's time again to put into practice what the last chapter has spelt out in theory, so here are some simple tasks to try out.

1 Depth of field is hard to understand in abstract terms, but much easier to see when you put it into practice. Grab a willing subject and see the difference in the amount of depth of field when you change the aperture (remember to correct your exposure by changing either the shutter speed or ISO).

2 Now repeat this exercise with a wideangle lens and then again with a long telephoto lens.

3 Remember to label each set with both the lens and aperture. Now compare your results by laying them in rows, or viewing them in rows on screen, with the wideangle set top, then the standard and long telephoto sets underneath.

4 Select the images from each lens that look to have enough depth of field for that portrait, make a note of the aperture and this will always be your starting point with each lens.

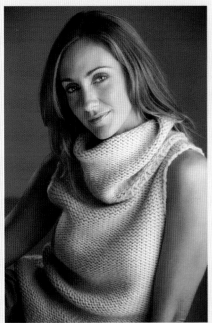

◄*Controlling depth of field is crucial in portraits. Here the subject is kept sharp while the background is rendered diffuse by a medium aperture.*

FOUR **LIGHTING**

Now that we've covered the basics of technique the most important secret to any great portrait is the lighting; get it right and it will flatter the subject, get it wrong and it will highlight the subject's flaws.

The Direction of Light

The best lighting pattern for portraits is often the traditional 45-degree lighting angle; it is based on the classical painters' styles and is also known as 'Rembrandt' lighting. It can be simply achieved with natural light or studio flash and once mastered it will make all your portraits look professional and natural.

Sighting the subject with the light falling on them from an angle of 45 degrees in front will light the five planes of the face – the forehead, chin, both cheeks and the nose – the touches of light applied to these areas will naturally thin the subject due to the shadows.

The 45-degree lighting pattern is everywhere; you just have to look for it. A window is the easiest place to apply it, as its position is fixed. The shade from the first tree in a wood will give similar opportunities for the same direction of light, but the camera must be carefully positioned to ensure that the light is coming from the correct direction.

High Light Sources

If the light source is too high you will see little or no detail in the eyes, often referred to as panda eyes, due to the dark patches created.

▶ Sometimes it is hard to see the direction of the light, so try to think of the light source being on a stick then it is easier to imagine the direction in relation to the subject, the camera and the light source.

▶ The profile is achieved by moving the camera position further away from the light source, however, it is only flattering if the subject has a shapely nose.

▼ If you want two-thirds of the face visible to camera and in slight shadow the camera position has to be moved to maintain the angle of the light. Make sure that the nose falls within the cheek.

USE STUDIO FLASH

While most people will content themselves with their camera's built-in flash or by investing in an external speedlight, if you want to take more professional portrait-style shots of your family then studio lighting is a must. It's worth noting that you can hire studio equipment, so if you want to take some special shots, but don't feel it's worth investing in professional lighting in the long term, then this is a good option.

The 45-degree lighting pattern is easier to see and apply with studio lighting as the studio flash can be positioned at the exact location and height. To achieve the best results a four-light set-up is perfect: a key light is the main light used to shape the subject with highlights and shadows; a fill-in light is used to control the shadow detail, depending on your required lighting ratio; a hair light is used to separate the subject from the background; and a background light is used to fully separate the subject from the background and add extra depth to the portrait. The ratio of power between the key light and the fill-in light controls the contrast in the subject, providing set amounts of detail in shadow and highlight. A ratio of about 3:1 between the key light and the fill-in light is perfect for most studio portraiture.

◀ *These four images illustrate some of the different lights that constitute a studio system. The top image shows a 45-degree lighting set-up while the second top shows the key light only, below that the back light only and at the bottom the hair light only.*

► *A two-thirds facial portrait is achieved by the subject moving their head away from camera slightly in the direction of the light source. To maintain the correct 45-degree lighting pattern the studio flash position also has to be moved in the same direction. Make sure that the nose does not cut through the cheek.*

► *Flat lighting a two-thirds facial portrait will cause the subject's face to look fuller if the key light is not moved when the head is turned to the two-thirds position.*

Profiles

A true profile is achieved by moving the head even further away from camera position, with no far cheek showing. Move the key light in the same way to achieve a 45-degree pattern. Because the key light is pointing back towards the camera position a lot of light will spill towards the lens; either use a good softbox or try using a snooted key light reflector.

▲ *A dramatic two-thirds facial portrait can be achieved simply by switching off the fill light. This will let shadows become darker and more dramatic, great for black & white portraiture.*

Window Light

▶ *A portrait lit by natural light through a window can have a unique and timeless quality.*

Seating the Subject

If the sun is high, the subject will need to be seated slightly lower than the window sill, to get a better quality of light on the face. Look for large frosted windows as this will give very diffused lighting. Use a large diffusion panel on sunny days to cut down on the harshness of the light.

Professional-looking portraits shot with just a camera and a reflector are really simple to achieve when you master the use of window light. When working inside a home or office I try to use a large window to light the subject. This technique is simple to apply and the results are practically guaranteed to give beautifully lit portraits if shot correctly. By using a large window, the light source is big enough so that the subjects can be lit full length as well as just 'head and shoulders'. There should also be enough light for a small group.

Light coming through a large window is my favourite kind of natural light, especially when a 45-degree lighting pattern (see page 84) can be applied to the subject. To get 45-degree lighting, the subject and camera have to be moved because of the fixed light source. To obtain the correct lighting pattern, the camera should be very close to the window wall and the subject positioned accordingly so the light from the window is at 45 degrees. If the subject is close to the light source, turn their shoulders away from the window to avoid any highlight detail becoming burnt out on the chest.

USE A REFLECTOR

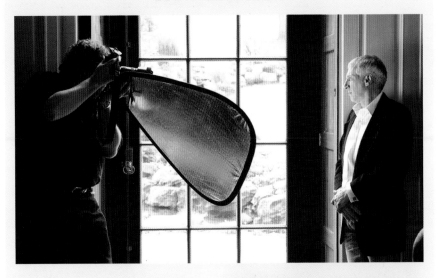

With the camera positioned against the wall and window the tri-grip reflector is used to bounce some of the sunlight back into the subject's face. Remember to readjust your exposure to compensate for the difference in illumination. Tilt it towards the window as well to control the shadow and not overlight the ear that lies in shadow.

▶ *The top image shows the shot without a reflector, with the resulting high contrast. The bottom shot shows the more even illumination obtained by using a reflector.*

High-key Lighting

Clean Backgrounds

In a studio set-up use a roll of white paper for a seamless background. Also make sure that the background is well lit, if the lighting on the face is under two stops brighter than the background, the background will not be pure white and its texture will be recorded.

The term 'high-key' describes an image that is light in tone overall, including, for portraits, the clothing when possible. The style is simple and when done right it gives very clean lines due to the background being brighter than the subject's face. High-key images are often just associated with studio photography, but they can be easily achieved on location using a light background or backlighting; however, it is more difficult to achieve a perfect high-key effect when there are several people.

▼ *High-key portraits are very graphic and have plenty of impact. Colour in the image will enhance the effect even more.*

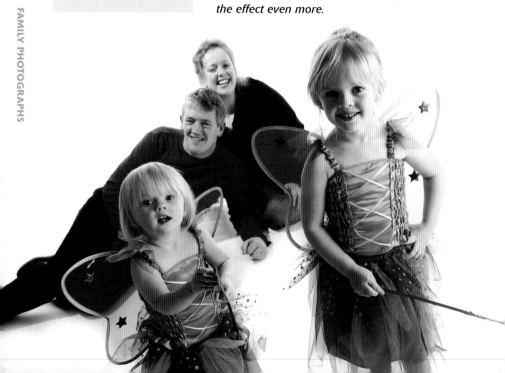

◀ *Shooting high-key images on location requires effective backlighting and a reflector.*

▼ *The best way of shooting high-key portraits in a studio is to use a four-flash set-up.*

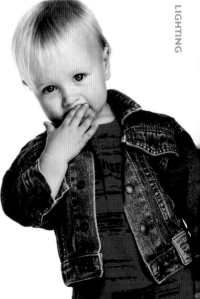

LOCATION HIGH-KEY

When trying to achieve a high-key effect with backlighting on a sunny day, use a white reflector to bounce back the light from behind the subject onto the subject's face. If you don't have a reflector use a speedlight to lift the detail in the subject's face, but try to get a two-stop difference between the face and the body.

STUDIO HIGH-KEY

Perfect high-key shots in the studio are achieved with a four-flash set-up, a fill light, a key light and two background lights. Set the fill flash half a stop less than the key light and set the background lights two stops brighter than the key light.

Low-key Lighting

▲ *A portrait in profile can be made very dramatic by using low-key lighting.*

When the overall image is dark the portrait is referred to as a low-key photograph. A low-key portrait is a traditional style of portrait photography that mimics artists such as Rembrandt who painted their subjects in darkened locations in order to bring more impact through emphasis on the highlights. Do not confuse a low-key shot with an underexposed image; the exposure still needs to be spot on, it is just that the overall tone is darker. This type of photograph needs a great deal of control to ensure that the lighting maintains the subtlety in the detail of the shadows.

Low-key situations give an image more impact in the highlights due to the small amount of light overall, giving a natural drama to the portrait; however, watch out for any highlights on the hands, as a low-key shot will increase the dominance of anything that catches and reflects light.

Slimming Light

A subject in dark clothes photographed in low-key light will look slimmer, because the eye does not get drawn to their shape by any bright clothing. If you are not sure about the amount of detail the camera will see, squint your eyes and the contrast will naturally be increased to mimic the effect of the exposure.

▲ Low-key portraiture is perfect in black & white especially if you give good tonal range to the skin. You can enhance the portrait by vignetting the image in Photoshop to take the eye straight to the brightest point in the portrait.

▼ If the overall tone of the portrait is more grey than black this is referred to as a mid-key portrait.

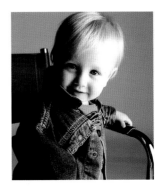

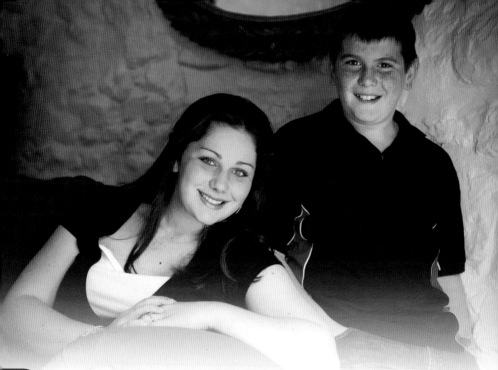

FIVE **PRACTICAL POSING**

The way that you pose and arrange your subjects will have an important effect on the overall look of your portrait. The way in which you use the natural curves of the body and limbs will set the overall mood.

How to Pose

Hiding Hands

If in doubt about how to pose hands, hide them – it's easier and quicker. Also, the side of the hand is more elegant than the back of the hand.

All poses start and end with the shifting of the subject's weight and balance; the feet and their initial position in relation to the camera will give either power or elegance to the image as well as a look of either comfort or awkwardness.

POSING FEET

The best starting point for most individual portraits is for the body to be slightly turned away from the camera, which makes for a slimmer subject. This position is naturally achieved when the back foot is turned to 90 degrees and the weight is positioned on this foot.

a) *Posing the feet square to camera will give a solid stance, but also a less elegant look.*
b) *When the weight is on the back foot, the front foot is used to maintain balance as well as finish the pose.*
c) *For a more feminine look, turn the front foot slightly away from camera and ask the subject to rest it lightly on the instep.*

POSING HANDS

There are some simple rules for posing hands, as a badly posed hand will detract from the subject and the mood as well as the expressiveness of the portrait. Even if you hide hands, leaving the thumbs out of the pockets will stop the whole hand from disappearing into the trousers.

◄ **a)** *Above the waist the wrist should be slightly bent to enhance the gracefulness of the pose.*
b) *In classic portraits finger stacking is an easy and elegant pose.*
c) *If the hand is allowed to drop and is seen flat to the camera it looks ugly and is referred to as a 'bunch of bananas'.*
d) *Hands can also be used to add expression and character to certain portraits.*

▲ *The male usually has a stronger and wider stance with a more powerful dynamic pose, which is achieved by exaggerated leaning and a more face-on position to the camera. Here are a few simplified poses that you can try out yourself, either on their own or perhaps in conjunction with another person or by putting them together in a group.*

▲ *The female pose is traditionally more graceful, with a more subtle posing of feet and hands. The body angle is usually slightly turned away from the camera, to give a slimmer portrait with the head dipping slightly to the front shoulder. Again here are a few poses that you can try out yourself, with single or multiple subjects.*

Posing Groups

Arranging a group no matter how big is quite simple if you use a triangular shape as your default when you pose the subjects. A group will test your skills as a photographer, but there are still three main things to worry about: light, pose and expression. To construct a successful group portrait, the subjects need to look like they are connected to each other, without being too close for comfort, so, by using simple designs of composition in the structure of the group, the subjects will have a connection.

Decide on the focal point within the portrait, often a parent as they will be one of the tallest and naturally dominate the group, then radiate the rest of the group out to the edges of the frame, turning them towards the middle and reducing them in height as they sit or stand.

▼ *Large groups are easier to construct if you try to keep them simple.*

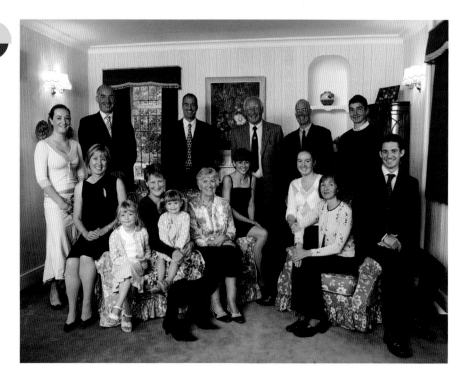

By having the tallest subject in the middle of the group, even if there is someone sat in front of them, the group will have a natural peak, which is the top of the triangle. The subjects positioned at the edges of the group, because they are lower, naturally give the other two points of the triangle. The same construction can be applied to large groups with the only difference being that the peak of the triangle might be slightly flatter because of more heads and the image will be shallower due to the stretched format.

Seated Subjects

When a subject is seated, try to avoid sitting them too far back in a chair as the pose can look slouched. If any of the subjects are very large and are sensitive about how they will appear in a photograph, you can try to disguise this by being sympathetic in the pose. Slightly conceal an overweight subject behind another subject, even sit a small child in front and for a very tall subject try sitting them down.

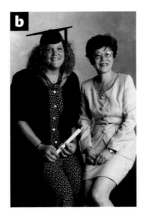

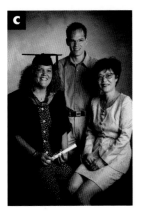

◀ **a)** *For an individual portrait, turn the body away from camera to make the subject more elegant,* **b)** *a second subject should mirror the first,* **c)** *for three slightly separate the two in front then position the third to fill the gap,* **d)** *for four people move the front subjects further apart to allow the back subjects to turn slightly.*

Posing Babies

▲ *When dressing up a baby, remember it will date quickly and embarrass them for the rest of their life unless it is classy.*

Tiredness

When the baby is becoming tired, take a short break. A quick drink for the baby can gain you another 10 minutes.

The main thing to remember when photographing babies is that they tire very easily, so the session needs to be quick, with the least amount of fuss with equipment. Portraits of babies are best kept simple, in both the props you use and environment; this will take little away from the impact of the child. Playing the fool is the only real way to get an expression as verbal requests will have no reaction, but your tone of voice often will. Expression will be made easier by modulating your tone as well as making silly noises.

NEWBORNS

Even if the baby is asleep the portrait will be beautiful: try to get some eye contact if possible, but don't forget little detail shots such as feet and hands. The baby is best posed lying on its back, in a basket or covered bean bag. Use a rattle to get the baby's attention.

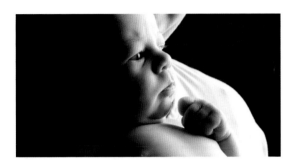

Details

Don't forget to shoot the little details with newborn babies. Shots of hands and feet and so on can add a lot to an otherwise similar selection of images.

◀ *Shots of newborns (top) have a lot more impact when the baby's eyes are open. Providing a slightly older baby (left) with some support can help obtain better eye contact.*

FIVE

101

PRACTICAL POSING

THREE TO SIX MONTHS

A baby will usually be able to lift its head at this age, so a covered bean bag is a great prop to allow the baby to have some support. The camera position should be just above the baby's eye-point; this will encourage the baby to lift its head to you. When the baby is beginning to sit, even with support, they can topple over, usually to the side and not forward, so have the parent close by. A noisy soft toy is still needed but the baby will respond to your tone of voice.

▼ *Babies who are starting to stand make for great shots with added interest when on their feet.*

NINE TO TWELVE MONTHS

At this age the baby will be trying to stand as well as sitting with confidence, so a chair or box is a great prop to use for support. Again a parent should be very close as the bigger they are the harder they fall. At this age babies will be more responsive to your tone of voice.

Posing Kids

Eye contact

Eye contact is a very important part of any portrait, but particularly so with children. Often shots taken from above lack any real emotion so get down to child's level for more natural eye contact.

Young children are great to photograph, especially as they start to show their own character and the pictures you take become the story of their growing up. The floor is always a great place to start with children; it's a more natural place for them to be and there is also less chance of any accidents, especially for an over-eager child. The best portraits are the ones that look most natural in pose and setting, so a longer lens may be needed at times to ensure that you don't interfere with their play. To gain a reaction, however, you will need to work close to the child, so decide what style of portrait you are going to take right at the start and choose your lens on that basis.

FUN ON LOCATION

Try to make your pictures a little more interesting, especially with older children. Here the subject was photographed against a yellow wall and I have included my shadow on the right as well as her dad's shadow with a sunflower toy to give the shot extra impact.

Fun is the key word for young children and play should be encouraged at some point during the session. This will give a lot more natural expressions, but to some degree you need to control their gaze into camera so you don't miss the shot. It is usually easier when shooting reportage-style photos to handhold the camera, so you can shoot more quickly.

The same things apply when working in a studio environment with flash; young children get so easily bored that it is essential to shoot the basic images that you need quickly, to allow you to the concentrate on more creative images.

▶ *Most parents are used to swinging their child for amusement but check this idea out with the parents first.*

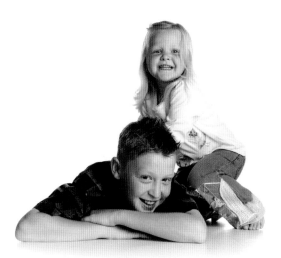

▲ *Remember to get down to a child's level. It makes for more natural shots and doesn't rely on any propping on location or in the studio.*

Dressing Right

A white T-shirt and blue jeans is a simple and effective dress code for children and adults alike when shooting more informal portraits. This clothing combination doesn't date too much and is plain enough to avoid detracting from the child themselves.

Posing Families

Clothing Style

Try and keep all the subjects in a similar style of clothing, as the choice of what to wear can be daunting for some families. Choosing either informal or formal clothes can set the style.

Observing a family before you even start to think about constructing the group is the easiest way to get a great family portrait; you will soon see the natural way a family is made up and who is close to whom. Traditionally the focus in nearly all family portraits is on the parents, so they are usually positioned in the middle of the group with the children radiating out to the edges. This will give a neat structure and a simple composition. Once you have tuned in your observational skills, you should be able to put any group together in minutes; keeping them together will tell you if you got it right as some families with teenagers can be a nightmare.

When the family is interacting I still try to have a pecking order in the group, paying attention to the composition and lighting all the time. Shots on location, such as walking through a park hand in hand, are great, but make sure the expressions are believable.

▼ *Keeping a family in a similar style of clothing lends an image unity.*

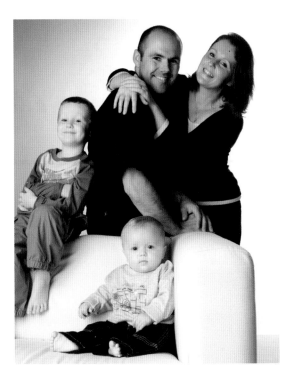

◀ *A sofa is a great prop to pose a family as a young child can be propped in the corner for stability giving the parents a chance to interact with each other.*

Tricky Families

If a family is being difficult to photograph, keep it simple, with any fussing with equipment kept to a minimum.

◀ *For more contemporary portraits the whole composition and posing is changed. This can be done simply by either making the children more dominant in the pose or by having the family interact with each other in a less formal way.*

Posing Siblings

When shooting young or older siblings, it often becomes apparent how comfortable they are with each other; posing them in a portrait will probably get many closer than they would like to be.

I usually start a session with children close to each other, but not touching, especially brother and sisters; this soon teaches me their boundaries for the rest of the session. Very young children will do almost anything and often snuggle up quite close to each other from the start, but teenagers are another ball game entirely.

The style of portrait will always determine the posing and lighting, whether it be relaxed or formal. Especially in a studio environment, I try and start each

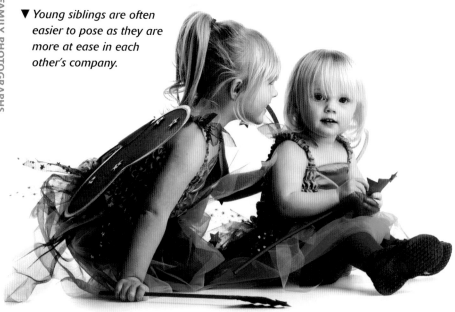

▼ Young siblings are often easier to pose as they are more at ease in each other's company.

portrait session with a simple series of poses, usually standing, that will allow the subjects to relax a little. If it's not your own family that you're shooting these first few minutes also allow you to pick up on personalities and characteristics through body language and chat.

Some posing of brothers and sisters will make it clear that they are related, but some poses can be a little ambiguous at times as to what relation the subjects are to each other. Not all brothers and sisters like each other so avoid physical contact if inappropriate. Concentrate on the youngest member of the portrait as they will probably have the lowest attention span.

▲ *A photograph of siblings should not allow one to dominate more than the other, except for creative reasons.*

◄ *Though some portraits are very formal I still try and instigate a few fun images at the end of the session, especially if the subjects are up for it.*

◄ *When kids tell me through their body language that it's time to separate I often instigate a little more play as this usually distracts them enough to get another portrait.*

Posing Adults

<< **SEE ALSO**
Seeing in black & white,
page 112

An adult will rarely want to have a portrait taken and they will almost never want to look as old as they are; due to the harsh realities of life good lighting needs to be applied to soften the effects of ageing. Different subjects of different ages will demand different styles of portraiture; for young adults a more contemporary image can be more in keeping with their lifestyle and with older subjects a more formal portrait can often be more appropriate.

Portraits of young adults can be as contemporary as their lifestyles dictate, just like their lifestyles at this point they will usually want to look young and fashionable.

▶ *Simple portraits are often the best place to start as they still show plenty of the subjects' characters.*

Keeping it Simple

Keep the portrait simple. A traditional portrait is a perfect place to start with grandparents as they will probably appreciate great lighting of the face to disguise the years. A seated portrait is a little easier for some grandparents, but make sure that there are no problems that might make posing in one position for a while uncomfortable.

Plunging necklines and bare shoulders can look very glamorous especially on younger women, but be aware of how the light catches the tops of the arms as this attire can make the arms look heavy.

Older people are great to photograph, especially if you are looking to show more of their character. I think it is usually best to flatter the subjects with lighting by adding a reflector in front of them to soften any wrinkles as well as using soft focus filter on the lens to soothe any lines.

▲ *Many adults wear glasses so pay attention to them and try to avoid unattractive reflections by altering their angle to the light, especially when using flash or a reflector.*

▼ *Interaction makes great pictures but don't forget the looking-to-camera shot. Bare arms can look great in a photo, but be careful with their positioning as they can look a little heavy if posed incorrectly.*

SIX **COMPOSITION**

With the camera doing almost everything for the photographer today, the difference between a good and a bad photograph is often the composition; so lets take a look at the basics.

The Basic Rules

Composing a Group

Pose the subjects so all the heads are at a different height, and then tilt the heads slightly towards the middle of the group, to make the eyes move away from a straight line.

The 'rule of thirds' is the most basic rule of composition; with respect to portraiture it basically means that the main subjects will dominate two-thirds of the portrait, with the other third being left to background. It is the subjects' positioning in the frame that will give this style of composition. It's more or less the same for a head-and-shoulders portrait where the space is left above and to one side, through to groups where the space is left again above and slightly to one side of the group.

Here are some questions that you should ask yourself before taking the photograph. Considering these issues should become second nature as your photography progresses.

1 Is the position of the main subject, the main point of interest in the picture?

▼ *The rule of thirds is a good starting point for strong compositions.*

2 Are there any distractions in the background that can easily be hidden with a slightly different camera position? Is the foreground distracting, and are there any elements that you are able to change or introduce?

3 Can you add more impact to the composition?

4 Will a tilting of the camera give a better dynamic?

◀ *A simple but effective composition can be achieved by placing the subject near to one side of the frame.*

◀ *An offset composition is one which should instantly give impact and a sense of creativity to a portrait. The subjects are positioned to one side of the frame, which leaves a lot of space, but when used with creative cropping and lighting the image has a strong dynamic.*

Seeing in Black & White

A black & white portrait gives instant impact to the image, and it will not take you long to start to see the scene and subject in tones of grey instead of colour. A portrait in monochrome often seems to be timeless, and the popularity and demand for the medium is greater than ever. The images tear away the reality of life and give an abstract vision as by nature we see everything in colour. Whether you shot in black & white or switched to monochrome in Photoshop your images can instantly look more creative.

A portrait will look so different in black & white especially if you choose a higher-contrast location and light source, as once the colour is removed blacks often

▼ *A classically posed shot in black & white with simple expressions will give a timeless image.*

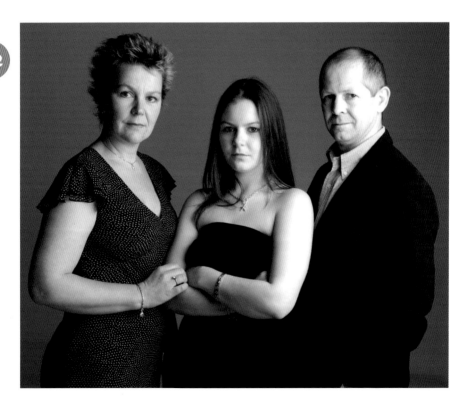

appear blacker and whites become whiter. A good black & white portrait should have a range of tone and detail across the whole image, and you should particularly pay attention to any distracting highlights in the background as there will be no colour to disguise them.

For more impact use a dark background, as this will focus all the attention onto the subject, but use a second light source to separate the subject from the background if possible.

▶ *Fun portraits in black & white are very trendy and give the feeling of being out of a magazine.*

CONVERTING TO BLACK & WHITE IN PHOTOSHOP

There are many ways in which you can convert your colour image to black & white using Photoshop, however, my favourite is to use the Channel Mixer. This is quite a quick way of making your changes, but it does offer you a lot of control.

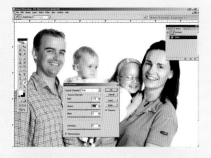

First open your image and select IMAGE > ADJUSTMENTS > CHANNEL MIXER.

Then click on the MONOCHROME check box, now adjust the sliders until you are happy with the effect. In this image setting the red slider to +72 and the green slider to +28 gave the effect I was after, and this is a good starting point for most images.

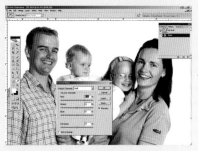

Using Props

Natural props can make a subject look more relaxed when posing as well as helping to give a more dynamic shape to the portrait. A prop introduced into the portrait can do two things: it can help to enhance the pose or it can tell us something more about the subject. Either way it should help the composition and the storytelling overall and not distract from it.

A prop used to pose the subject can be as simple as a chair or a set of steps, even a wall can be used to lean or sit on. The prop in this situation should always appear natural or sympathetic to the location. In a studio environment keep propping simple, as it is very easy to

▲▶ A prop such as the cello above or the cricket bat and helmet to the right, can be used to tell the viewer lots about the personality of the subject.

'over prop' a portrait with plants and boxes. Think about the overall design, and always question the use of unfamiliar props.

Props can also be used to add detail to a portrait, such as jewellery or a hat; even a vase of flowers introduced into a portrait to add colour is considered a prop. Sometimes a subject will request that a certain item be introduced into the portrait such as a walking stick or a musical instrument. If so try to use them firstly as a secondary interest and then for creative reasons in order to add more impact.

Subtle Props

Make sure that any prop used in a portrait does not dominate the image, unless of course it is being used for that effect. A prop should complement the subject rather than overwhelm them.

◀ *Studio posing stools make seating arrangements easy as they change the subjects' heights in groups.*

▲ *A log or fallen tree trunk is a simple and effective prop when on location.*

◀ *Try using slightly unusual seats or other props to create fun portraits.*

Backgrounds

High ISOs

If you are shooting a portrait with lots of detail you may be able to use a higher ISO as the grain is less visible due to the lack of flat tone areas. This will allow you to use a faster shutter speed or a narrower aperture if you need them.

The choice of background is a key element in any family photograph, so it is important to pay full attention to what is going on to avoid any unwanted distractions. A background should be chosen to tell a story, especially when working in a home or at a special occasion. The background should add to the overall impact of the portrait design with the use of shapes and colour. It is important to use any location to its best advantage; time should be taken to consider the camera angle and viewpoint to get the best composition and framing of the portrait.

▼ *A background with a bold colour instantly creates dramatic look, this can be enhanced further with strong lighting as seen here with the harsh sunlight coming through a window.*

KEEP IT SIMPLE

Keeping it simple is again the secret to any background choice whether in a studio, at home or on location; if a contemporary portrait is required then look for clean lines and a plain background. A background does not have to be white to be contemporary, a bold colour is often a great choice, even graffitied walls; just make sure there is nothing to draw the eyes away from the subject.

Lens choice and aperture will play a big role with background choice, as controlling the depth of field is essential when working on location. A wide aperture and a long lens can throw most distractions out of focus.

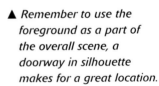

▼ *Even a contemporary home can look a little busy, so try to keep the background as simple as possible.*

▲ *Remember to use the foreground as a part of the overall scene, a doorway in silhouette makes for a great location.*

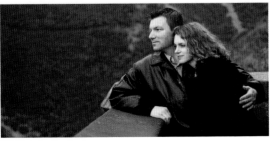

◄ *A long lens is great to throw a background out of focus quickly.*

Outdoor Portraits

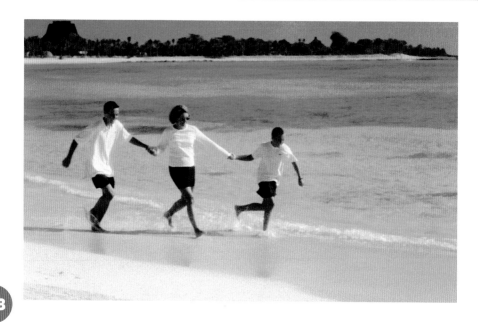

▲ *Shooting family portraits outdoors can add some vitality to your shots.*

Outdoor Tips

When shooting a group make sure that sunlight does not cast any harsh shadows or highlights across the faces as this will make it very hard to take attractive photographs.

You don't need bright, sunny days to take great portraits outside; you do need, however, to observe the quantity and quality of the light. Choosing a location with some shade and shelter is an important factor so you can shoot any time of year and give natural soft lighting to the subjects. On sunny days any location can be used but harsh shadows can be caused on the subject or if they are backlit there will be a lack of contrast on the face unless a reflector is used.

A wooded area is a perfect location especially in the spring and autumn when the colours are crisp; on sunny days the subjects can step into the shade of a tree to protect them from harsh sunlight. Even on a cloudy day the first tree in a wood is perfect because the shade of the tree gives a direction to the soft available light.

The beach is an excellent choice of location any time of year as only the colour of the light will change over the seasons, being warm in summer and cold in winter. The end of the day is always the best time to shoot as shadows are longer and the light is warmer. If you are trying to capture detail in the sky you will need to light the subject so that the meter reading from them is roughly equivalent to that from the sky. This is best done with off-camera flash, coming from a similar direction as the setting sun. Turning the subject's back to the sun will lift the overall tone of the background, and remember to use a reflector or fill-in flash to light the subject.

◀ *Avoid windy days on the beach as there is usually little shelter.*

▲ *Spring and autumn are great times to photograph in a woodland location.*

▼ *Look for alternative viewpoints when shooting on location.*

3

DIGITAL IMAGE
PROCESSING

- Digital Enhancement

SEVEN **DIGITAL ENHANCEMENT**

The computer is largely replacing the darkroom and the main difference between the two is that techniques used in the darkroom for decades, such as dodging, burning and cropping, can now be performed, along with more complicated tasks, in a fraction of the time and with much more consistency.

Before we start looking at digital enhancement, it is important to remember to treat an image as if we were using traditional darkroom techniques with film. By doing this most of the basic work will still be done in the camera, leaving little to do in post-processing. If an image needs cropping to enhance the composition then crop it, if you need to lighten darker areas to lift shadow detail or darken areas to take away distracting highlights, then do it, but when an image is poor it will always be poor no matter what we try to use to correct the mistake. The emphasis should be on getting it right in the camera, using digital manipulation to take the image to the next level of creativity or beauty and not on trying to make a silk purse out of a sow's ear.

There are many software programs that will enhance the photographic image such as Painter and Photoshop Elements, however, the professional version of Photoshop is the industry standard and is most professionals' choice due to its advanced functions. This chapter is based on Photoshop CS2 using a PC, but most of these tasks can be carried out in other versions of Photoshop or indeed in other software packages.

▼ *Graphics tablets such as those from Wacom are available in different sizes to accommodate your working environment and even include a wide-format tablet for use with multiple monitors.*

✔ Only make simple corrections to the image if possible and keep the effects to a minimum.

✔ Try to avoid making the picture much bigger as this will degrade the sharpness and quality.

✔ Decide on a logical order of manipulation as this will stop you having to go back and redo basic things such as cropping.

✔ Save your image often and with a different file name when manipulating it, this will allow you go back to the original or a saved image at almost any stage.

✔ Layers are a powerful tool; learn how to use and save your images using different layers of progress and manipulation.

✔ Calibrate your system often, just follow the instructions that came with your monitor, cameras, scanner and printer. This will allow a good colour workflow and a better consistency from camera to print.

✔ Retouching the face can have the drastic appearance of plastic surgery gone wrong, so make gradual changes in stages and on different layers so you can blend the effect to make the image look real.

✔ Back up your work to CD or DVD, especially the original files and finished photographs, as this will allow you to go and retrieve your images at a later date or after a hard drive failure.

✔ RAM is a key requirement of Photoshop, so make sure you have lots of memory in the computer.

✅ Adjusting Brightness and Contrast

A well-lit portrait should have a full tonal range from white to black. If it's not possible to get the perfect exposure in-camera then alterations in exposure and contrast can be made in Photoshop.

◀ *Before adjusting brightness and contrast.*

▼ *After adjusting brightness and contrast.*

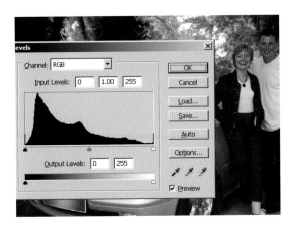

Raw Tips

If shooting in a raw format make any exposure and contrast adjustment in the raw software, as the adjustment is quicker and more accurate.

If you have several similar images to adjust press the alt and L keys together and the same contrast adjustment will be applied again.

1 IMAGE > ADJUSTMENTS > LEVELS

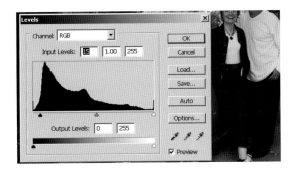

2 To set your black point, drag the left slider (black) towards the histogram until it touches the solid mass. Look at the image as the preview will change as you slide the cursor towards the centre.

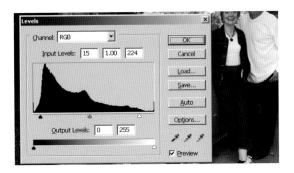

3 Now set the white point by dragging the right slider (white) towards the mass of the histogram. Again watch the preview then click OK. If the image is too contrasty, you have probably moved the sliders too far towards the middle.

✅ Adjusting Colour

When photographing in different locations and weather conditions colour varies quite considerably, but it is not a problem to get back to a neutral overall tone using simple Photoshop techniques.

▶ *Before adjusting colour.*

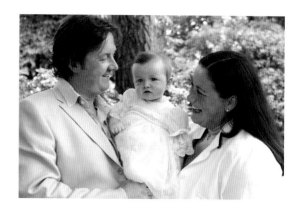

▼ *After adjusting colour.*

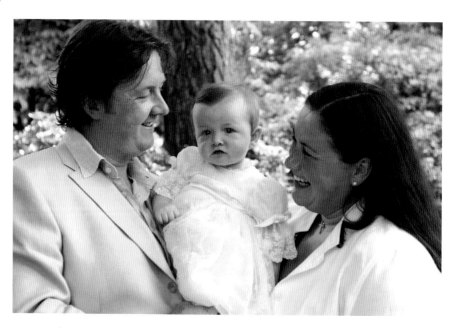

White Balance

Test out the best white balance setting in camera, as adjusting the white balance over lots of images can be slow and inconsistent.

1 IMAGE > ADJUSTMENTS > LEVELS

2 Select the middle picker icon (set grey point) by clicking it.

3 Position the cursor over something just off white or near 18% grey on the image and then click. The colour has now been adjusted in the preview, if the colour still seems off, click another area. (Press and hold the alt key for the reset option.) Watch the preview for critical adjustment, then click OK.

✅ Adjusting Hue and Saturation

▲ *Before saturation adjustment.*　　▲ *After saturation adjustment.*

To give more impact to an image simply adjust the colour saturation to give brighter and more vivid colours as well as slight shifts in the overall tone.

128

1 IMAGE> ADJUST> HUE & SATURATION

2 To increase the saturation of colour move the slider to the right, usually no more than +20. Subtlety is the key, and if the preview box is ticked you will see the transformation in colour instantly. Click OK when done.

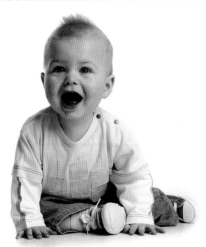

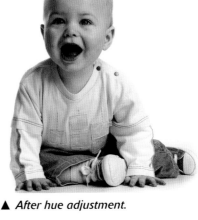

▲ *Before hue adjustment.*

▲ *After hue adjustment.*

If you are struggling with colour balance, try shifting the hue slightly; often + or −5 will make a significant change, especially in a portrait.

1 IMAGE> ADJUST> HUE & SATURATION

2 To increase the amount of red in the image, slightly move the slider to the left (0 to −5), too far left and the subject will go magenta. To increase the amount of yellow in the image slightly move the slider to the right (0 to +5), too far right and the subject goes green. Click OK when done.

✅ Cropping the Image

If you want to increase the impact of your portrait in composition or to simply crop something distracting out, the crop tool in Photoshop will do it with a click-drag-click.

▶ *Before cropping.*

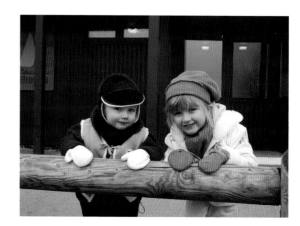

▼ *After cropping.*

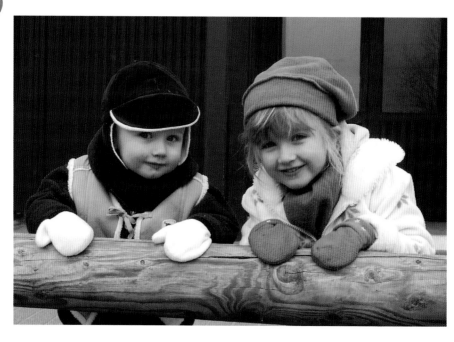

1 Select the crop tool from the tool palette.

2 Hold down the left mouse button and drag the box around the area you require, the crop area outside the box will be darker. When released you can reposition the cropping box by clicking inside the 'crawling-ant' line, as well as dragging any side. Double click or press enter to perform the crop, or press escape to cancel.

CROPPING TIPS

Cropping should be one of the last things you do to a portrait, as there is nothing worse than applying a lot of work to an image and then realizing the format is wrong in some way.

You can also set a specific size to crop to; this is done in the tool options section at the top of the Photoshop window. Select the crop tool from the tool palette. Select the width and height as well as the resolution. Hold down the left mouse button and drag the box around the area you require; you will see that the crop ratio is defined and you cannot manually adjust just one side. When released you can still reposition the cropping box by clicking inside the crawling-ant line and the overall crop by dragging a corner in and out. Double click or press enter to perform the crop, or escape to cancel.

When setting the resolution be careful not to crop too tight as the image may actually end up interpolating itself bigger, which will give a slight loss in quality.

✔ Removing Dust and Clutter

◀ *Image with clutter.*

Dust is a real problem with DSLRs, but it's easy to get rid of it with Photoshop. The clone stamp tool and the healing brush will remove dust specks as well as any unwanted items or clutter quickly.

▼ *Clutter retouched.*

1 First of all open your image, then select the magnifying tool, double click it, to see the image at 100%. Select the clone stamp tool or the healing brush from the palette.

2 Select a suitable brush from the drop-down menu, big enough to cover the dust spots and slightly soft, to allow a feathering of the tool so it does not leave a definite shape.

3 Press and hold the alt key and click on a section of the image near to the dust spot; this is where the stamp tool will clone from. Let go of the alt key once selected.

4 Now click the stamp tool on the dust, and it's gone.

✓ Drawing, Selecting and Retouching

The more retouching you do in Photoshop the quicker you will become as you hone your skills; however, a mouse is not as accurate as a pen, the tablet is pressure sensitive to the pen but it also has fingertip access to frequently used key-stroke commands to improve your workflow.

▼ *One of the pen and tablet's best features is the eraser tool on the top of the pen. Automatically when the pen is turned upside-down and pressure applied onto the tablet, it to acts instantly as an eraser, allowing for quick corrections especially if using the 'erase to history' option in Photoshop.*

When you start in Photoshop there are many great filters to change your image, however, when you have stopped playing about with all the fancy tricks much of your time will be spent drawing around a subject to mask and protect areas. I use a Wacom pen and tablet which is more accurate than a mouse when making selections. The pen acts just like a normal pen with a nib: as you apply different pressures on to the nib, the brush automatically changes to apply more or less colour when pressure is applied. The shape and size can also be adjusted on the finger button on the pen.

1 Selecting around the subject can be a tiresome job but it has to be done, so make it simple. Make a new 'levels adjustment layer' LAYER > NEW ADJUSTMENT LAYER > LEVELS

2 Now move the left and right sliders towards the middle to create a lot of contrast, thereby making it easier to see defined edges.

3 Use the magnetic lasso tool to draw around the subject, join up to the first point and your selection is complete.

4 If you do not want a hard edge to the selection, add a feathering to the selection by SELECT > FEATHER and add 5–10 for a subtle feathering or more if you prefer a strong dissolve.

Sharpening an Image

Raw Sharpening

While you can make sharpness adjustments before processing in the raw software it is best left until after making any alterations in Photoshop.

Some digital cameras apply sharpening to every image to disguise the inherent softness, but if possible sharpening is best left to the end of any manipulation, to avoid any loss in quality through over-sharpening.

Sharpening should either be applied to overcome any softness or for correction to an image due to slight camera shake. Photoshop has excellent sharpening options, especially the smart sharpen option, which has good edge detection and can improve the appearance of blur caused by slight camera shake.

▼*Before sharpening.*

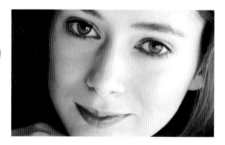

▼*After sharpening.*

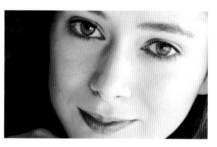

1 FILTER > SHARPEN > SMART SHARPEN

2 Choose the motion blur option. Now set the angle percentage to match the direction of the blur and the amount percentage for how much sharpening you require along with the pixel radius to be affected. If the preview box is ticked you can see the alterations as they happen. Click OK to apply the filter.

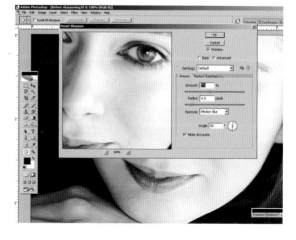

Presenting the Image

Last but not least is the final presentation of the images. Adding key-lines and borders around the image makes a big difference and finishes the portrait. There are many ways to do the same thing in Photoshop.

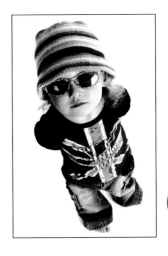

1 Crop the image to the desired size (see page 130).

2 After selecting all (SELECT > SELECT ALL EDIT > STROKE) choose the colour and size of key line and set the option to inside. Click OK.

3 IMAGE > CANVAS SIZE Set your width and height as well as the colour of the increased canvas size. Click OK.

Useful Information

USEFUL COMPANIES:

Adobe
www.adobe.co.uk – UK
www.adobe.com – USA

Calumet
www.calumetphoto.co.uk – UK
www.calumetphoto.com – USA

Canon
www.canon.co.uk – UK
www.usa.canon.com – USA

Fujifilm
www.fujifilm.co.uk – UK
www.fujifilm.com – USA

Kodak
www.kodak.co.uk – UK
www.kodak.com – USA

Lastolite
www.lastolite.com – Global

Lee Filters
www.leefilters.com – UK
www.leefiltersusa.com – USA

Mamiya
www.mamiya.co.uk – UK
www.mamiya.com – USA

Nikon
www.nikon.co.uk – UK
www.nikonusa.com – USA

Olympus
www.olympus.co.uk – UK
www.olympusamerica.com – USA

Panasonic
www.panasonic.co.uk – UK
www.panasonic.com – USA

Pentax
www.pentax.co.uk – UK
www.pentaxusa.com – USA

Quantum
www.qtm.com – Global

Samsung
www.samsung.co.uk – UK
www.samsung.com – USA

Sigma
www.sigma-imaging-uk.com – UK
www.sigmaphoto.com – USA

Sony
www.sony.co.uk – UK
www.sony.com – USA

GENERAL PHOTOGRAPHY:

Mark Cleghorn
Photography by Mark Cleghorn
www.markcleghorn.co.uk

Photographers' Institute Press
Photography books and magazines
www.pipress.com

Glossary

Adobe Photoshop The standard image-editing program.

Ambient light Light that is from existing sources within the scene.

Aperture The opening through which light passes to expose the film or sensor; it is denoted relative to the focal length in terms of f-stops.

Aperture-priority mode In this mode the photographer chooses the aperture and the camera calculates shutter speed. If the aperture or light level alters, the shutter speed is changed automatically.

Aperture ring A ring on some lens barrels that controls the aperture.

Aspect ratio The ratio of a frame's width to its height.

Barn doors A studio flash attachment to control the spill of light.

Bracketing Exposing a sequence of frames (normally three) of the same scene at different exposures.

Centre-weighted metering A metering system that weights most of its reading in the centre of the frame.

Colour temperature The colour of light described by comparison to that emitted by a source at a temperature denoted in degrees Kelvin (K).

Cropped sensor A digital sensor that is smaller than a 35mm frame.

Depth of field The amount of an image that is acceptably sharp from foreground to background. Depth of field extends one-third in front of and two-thirds behind the point of focus.

Depth-of-field preview Some camera models allow you to stop down the aperture to check depth of field before shooting.

Ev (exposure value) A unit of value for the overall exposure.

Exposure The amount of light that strikes either the film or sensor.

Exposure compensation A function that allows the adjustment of the overall exposure value relative to the setting that is recommended.

Field of view The amount of a scene that a lens will include within an image.

Flare Non-image-forming light that reflects off the internal elements of a lens barrel and scatters to form coloured shapes and cause a general loss in contrast. The risk of it occurring can be reduced by using quality lenses and a lens hood.

f-numbers The series of numbers that denote the size of the aperture in relation to the focal length of the lens in use.

Focus lock The mechanism that allows autofocus to be locked after it has achieved focus so that a scene can be recomposed without the point of focus altering.

Gobo A shape which can be attached to the light source to modify the flash output to that shape.

Grain The visible silver deposit that forms the photographic image on film, which is more visible on faster film.

Honeycomb attachments A studio flash attachment to create a straighter less diffuse beam.

ISO The International Standards Organization standard measure for film and sensor sensitivity. It is a measure of how fast a sensor or film reacts to light and therefore is the base for the calculation of exposure variables.

Lens hood An item of equipment that is attached to the front of the lens to prevent light from outside the angle of view from entering the lens and resulting in flare.

Megapixel A megapixel is equal to one million pixels. The resolution of a digital camera is usually given as the number of megapixels on its sensor.

Memory card A removable storage device that is used in digital cameras. Available in many different formats, the one that you require will largely be determined by your camera.

Mid-tone A tone that reflects 18% of the light falling on it.

Monobloc flash A flash unit that has the power control built into the flash head.

Multi-segment metering
A metering system based on readings from a number of different segments of the frame. The more complex the system the better the results. This is the default system for most cameras. More advanced models will combine brightness readings, with distance and colour information.

Noise The appearance of randomly distributed dots or variations in colour within a digital image; increased by both long shutter speeds and high ISO ratings.

Overexposure When too much light strikes the sensor or film the image will be left looking too light, this will result in lost detail in the highlight areas.

Parabolic heads A studio flash head that creates a slightly softer light.

Pixels An abbreviation of 'picture elements', which are the individual components that make up a digital image.

Prime lens A lens of a single, fixed focal length.

Reciprocity The fact that the overall exposure value can be maintained despite changes to its composite variables, because a change in one exposure variable can be compensated for by an equal but opposite change in the other.

Reciprocity failure A problem that occurs during long exposures shot on film. As exposure times increase beyond one second film becomes progressively less sensitive and the law of reciprocity begins to fail, therefore requiring positive exposure compensation.

Reflectors Generally sheets of material held rigid by a frame that are used to reflect light from the source back onto the subject.

Shutter-priority mode In this mode the photographer chooses the shutter speed and the camera calculates aperture. If the shutter speed or light level alters, the aperture is changed automatically.

Shutter speed The duration for which the shutter is open, exposing the sensor or film. It is expressed in seconds or fractions of a second.

SLR (single lens reflex) A type of camera that allows you to see the image through the camera's lens as you look through the viewfinder.

Snoot A cone-shaped attachment to narrow the light output from a studio flash.

Softbox A studio flash attachment used for softening light.

Speedlight A small flash unit that is attached to the hotshoe on the top of a camera.

Spot metering A metering system that measures from a small part of the frame.

Standard lens A lens that gives an angle of view that is similar to that of the human eye.

Telephoto lens A lens that has a narrower angle of view than the human eye and therefore makes subjects appear magnified.

Through-the-lens (TTL) metering The metering system built into cameras that reads the level of light entering the lens in order to give an exposure value.

Underexposure When too little light strikes the sensor or film the image will be left looking too light, this will result in lost detail in the shadow areas.

Umbrella A studio flash attachment used for softening and directing light.

Vignetting The darkening at the corners of an image which is either the result of a lens hood or a filter mount impinging on the field of view, or by a fall-off in light caused by the lens.

White balance The function on a digital camera that enables you to balance the way in which colour is recorded in order to accommodate the different colours of light that are emitted by different light sources.

Wideangle lens A lens with a wider angle of view than the human eye.

Zoom lens A lens that has a variable focal length as opposed to a prime lens which has a fixed focal length.

Index

photographers'
pip
institute press

To request a full catalogue of Photographers' Institute Press titles, please contact:

**GMC Publications, Castle Place, 166 High Street, Lewes,
East Sussex BN7 1XU, United Kingdom**

Tel: 01273 488005 Fax: 01273 402866

www.pipress.com